IMAGES of America
ARROYO GRANDE

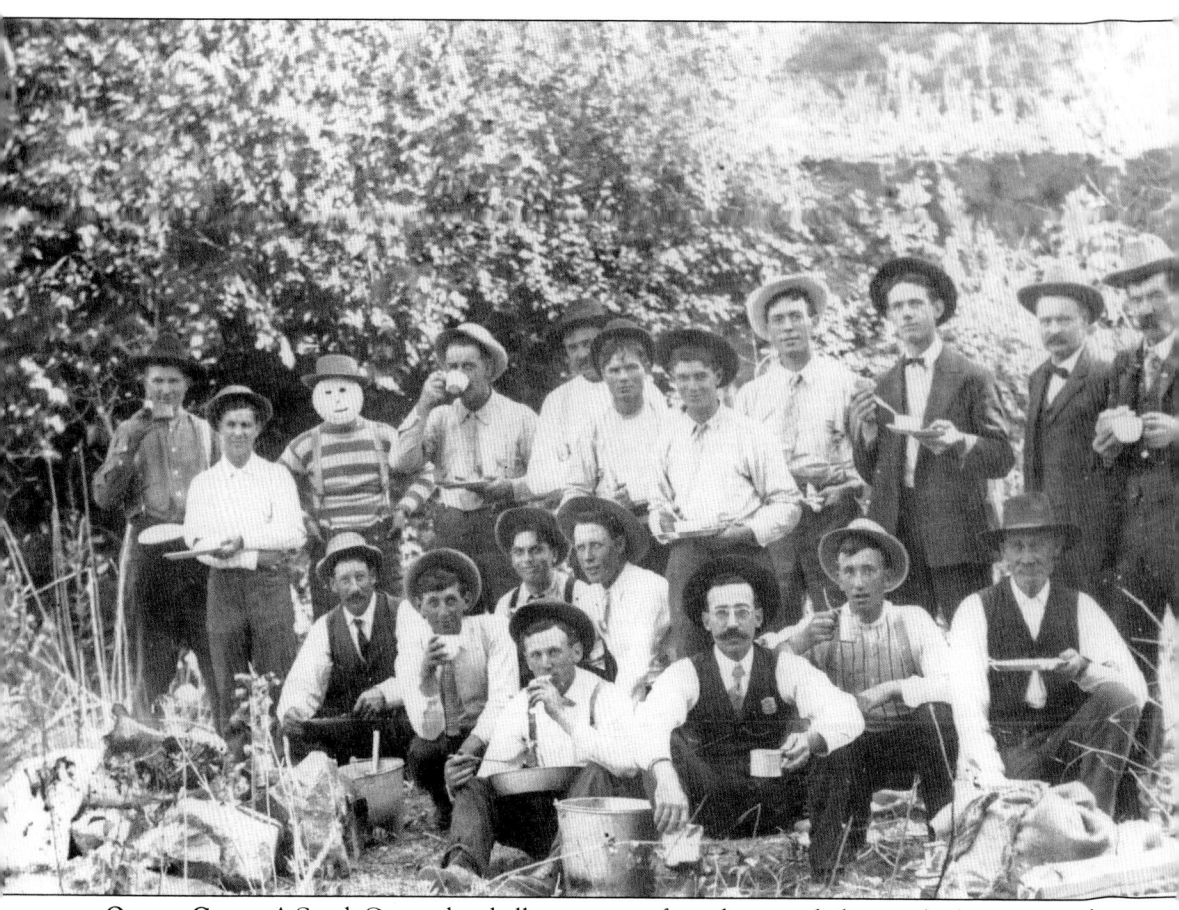

ON THE COVER: A South County baseball team pauses for a photograph during a barbeque around 1907. Members include, from left to right, (first row) Ralph Dalessi and D. C. Gale; (second row) Charles Dalessi, Ormand Lacefield, Harry Fowler, and Tib Fisk; (third row) Arch Beckett, Lee Wood, Dell Reiger, Mr. Reiger, Harry Cheatle, Earl Wood, Burt Fowler, Charles Keiger, and three unidentified. (South County Historical Society.)

IMAGES of America
ARROYO GRANDE

Jean Hubbard and Gary Hoving
South County Historical Society

Copyright © 2009 by Jean Hubbard and Gary Hoving; South County Historical Society
ISBN 978-0-7385-6944-4

Published by Arcadia Publishing
Charleston, South Carolina

Printed in the United States of America

Library of Congress Control Number: 2008941497

For all general information contact Arcadia Publishing at:
Telephone 843-853-2070
Fax 843-853-0044
E-mail sales@arcadiapublishing.com
For customer service and orders:
Toll-Free 1-888-313-2665

Visit us on the Internet at www.arcadiapublishing.com

Images of America: Arroyo Grande is dedicated to the people of Arroyo Grande and the members of South County Historical Society.

CONTENTS

Acknowledgments		6
Introduction		7
1.	Rancho Days and Mexican Land Grants	9
2.	The Founding of the Town	15
3.	Formation of the City	57
4.	Over the Freeway and into the Country	83
5.	South County Historical Society	111
6.	Centennial Celebration	125

Acknowledgments

The authors express their sincere appreciation to the South County Historical Society for their unending support of the book project. Unlimited access was permitted to records, photographs, and previous works of the society, assisting in the creation of this book. The board of directors and book committee approved and supported the project without hesitation. Development of this project was aided through the assistance of many people and organizations throughout the community. Our appreciation of them is expressed here, and our only hope is that no one has been overlooked.

Photographs and information were provided through many sources, including the following: Mary Bassett of the City of Arroyo Grande; Charles Porter of Porter Ranch Company; Jean Hubbard Collection (JH); South County Historical Society Collections (SCHS); Paulding History House Collection (PHH); Gary Hoving (GH); Vivian Krug; Gordon Bennett of Bennett-Loomis Archives; Howard Mankins; Mullahey Ford Dealership; Chang Reynolds; the 1883 *History of San Luis Obispo County*; *The Story of San Luis Obispo County*; San Luis Obispo County Historical Society; Dan Martin; Billie Swigert Records and Swigert Collection; Clayton Conrow Collection; Jack English; Carrol Pruett; Methodist Archives; Boswell Photograph Collection; Smithsonian Institution; San Luis Obispo County Title and Trust Company; Don Gullickson Family Collection; Dick Blankenburg of the *Herald*, *Times-Press-Recorder*; Donna Hunter; Bill Hart; Iketa family; Gillco Sales; Ross Kongable; George Pasion; Record Family Collection; Jeanne Frederick; Certified Freight Lines; Michael De Leon; Tomooka family; Kadama collection; Jan Scott; Crystal Hoving; Anita Garcia; Joan Sullivan; Chief Jim Clark; and Jane Line.

INTRODUCTION

The area known as Arroyo Grande was originally occupied by the Chumash Indians. These natives of the Americas lived in villages that dotted the California Central Coast and were usually located next to a water source. Archeological studies have found remnants of their culture throughout the region, uncovering pottery, arrowheads, and human burial sites.

Fr. Junipero Serra was sent from Spain to settle the region through a series of Catholic missions. His efforts constructed Mission San Luis Obispo de Tolosa and Mission San Miguel within the area later to become San Luis Obispo County.

Under Mexican rule, California land was made available to settlers in the form of grants beginning in 1837. The early grants were claimed by rugged people who ranched and farmed the area and were completely self-sufficient. Access to the county was primarily through ship landings, as roads through the region were sparse and treacherous.

As people began moving into the region to take advantage of the fertile soil, the need for additional services was born. Arroyo Grande sprouted a variety of services, including stables, a hotel, a bar, a mercantile, furniture making, undertaking, and even doctors. Eventually, the arrival of the railroad made Arroyo Grande the hub of commerce for all of southern San Luis Obispo County.

Growth of a community often increases the need for services. Roads, firefighting, and police were necessary to ensure the quality of life of the residents and visitors to the town. The decision to incorporate the City of Arroyo Grande was made through an election in 1911. Incorporation was approved by the voters with a margin of only two votes, launching the thriving city that we know today.

The City of Arroyo Grande has worked hard to provide the finest services and programs to the community. It has successfully managed growth while maintaining the charming character of the small community.

As we visually travel through the changes in Arroyo Grande, the unique character of the community becomes apparent. While there are many new homes and businesses, our heritage remains intact all around. It is easy to image what it would be like to walk down Branch Street 100 years ago with so many of the original buildings surviving. The specialty shops and services in the village area have not yielded to the large commercial ventures that could endanger the historic village. To the contrary, much of the downtown village area has been historically enhanced through parks, museums, and the creek walk.

Many of the improvements and restorations have been accomplished through the good works of the South County Historical Society. Volunteers donate thousands of hours of service per year to maintain and staff the museums and historic sites throughout the community. Collaborating with the city government to create a heritage square with historic buildings, museums, and a schoolhouse, the South County Historical Society is a remarkable, active community service

organization. Their efforts are further enhanced through the outstanding working relationship with other service organizations, including Kiwanis, Rotary, Business Improvement Association, and the chamber of commerce.

Those who live in and frequent the City of Arroyo Grande will surely agree that they have been blessed with one of the most beautiful communities in all of California.

One
Rancho Days and Mexican Land Grants

Under Spain, the land now known as Arroyo Grande was held for the king and used by the missions. Fr. Junipero Serra founded the Mission San Luis Obispo de Tolosa in 1792. Soon large herds of cattle roamed the hills. Wheat was planted in Lopez Canyon, then called el Triago. Deer competed and won. At the mouth of Correlitis Canyon, where the Arroyo Grande creek had for years deposited fertile soil, the Mission Indians tended vegetable gardens. In 1833, Mexico, with the Decree of Secularization, closed the Mission Period and opened thousands of acres of land grants to settlers.

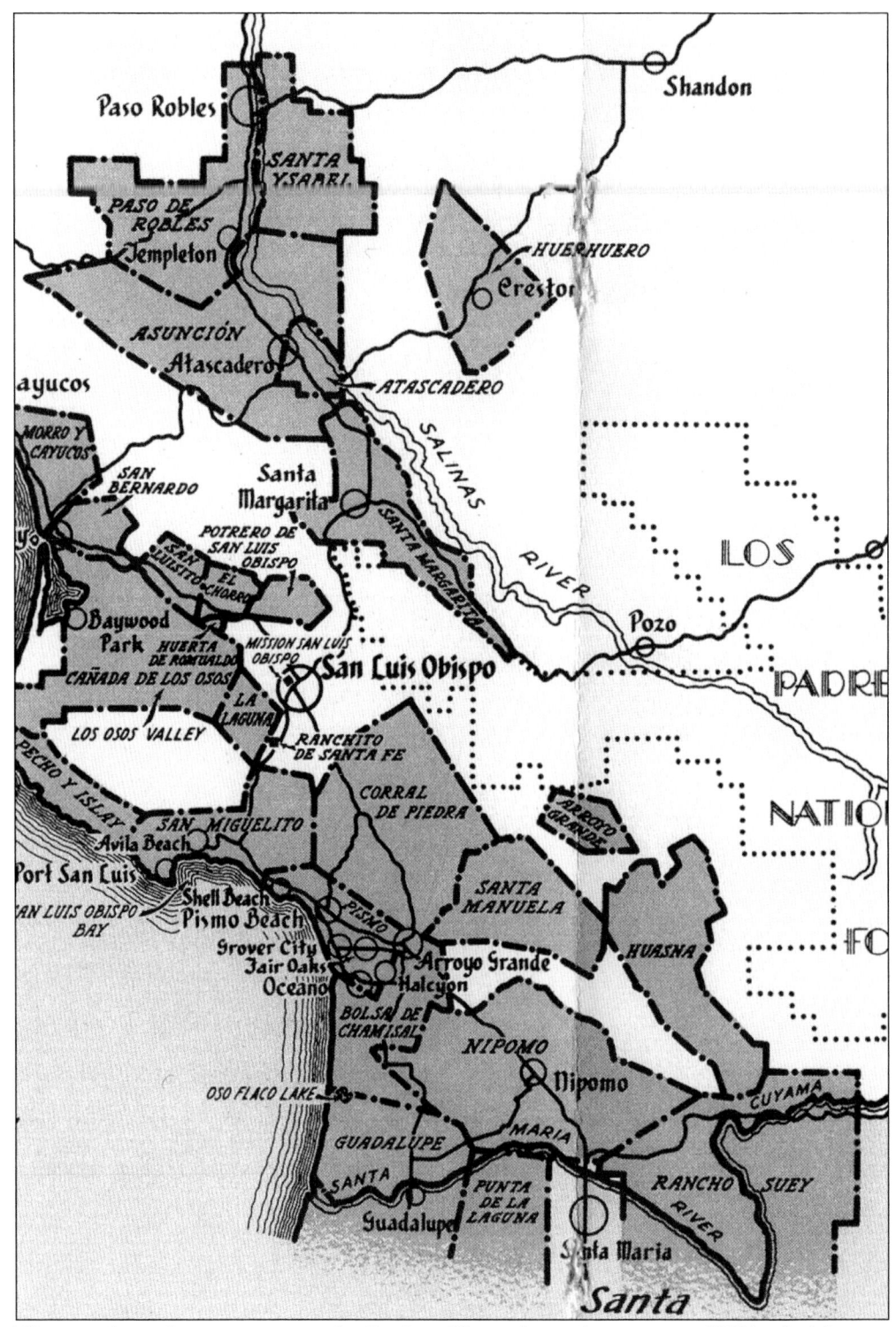

This map shows the grants given in the San Luis Obispo district beginning in 1837 by the Mexican government. (*The Story of San Luis Obispo County*, Title and Trust Company.)

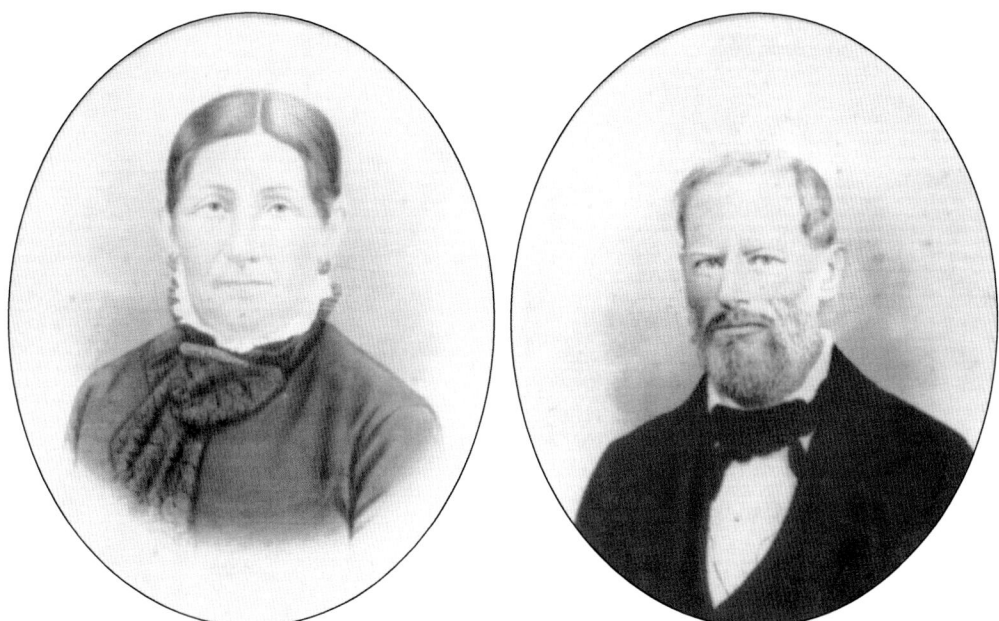

Francisco Zeba Branch was a New Yorker who came to California in 1831 with the Wolfskill party. Successful at sea otter hunting, he established a trading post in Santa Barbara. He courted the beautiful Manuela Carlon and applied to become a Mexican citizen while studying the Catholic religion. They were given the 16,954-acre grant in April 1837. Besides the grant he called the "Rancho Santa Manuela," he purchased the Bolsa de Chamisal, parts of the Corral de Piedras and El Pismo, and all of the San Ramon. (Anita Garcia.)

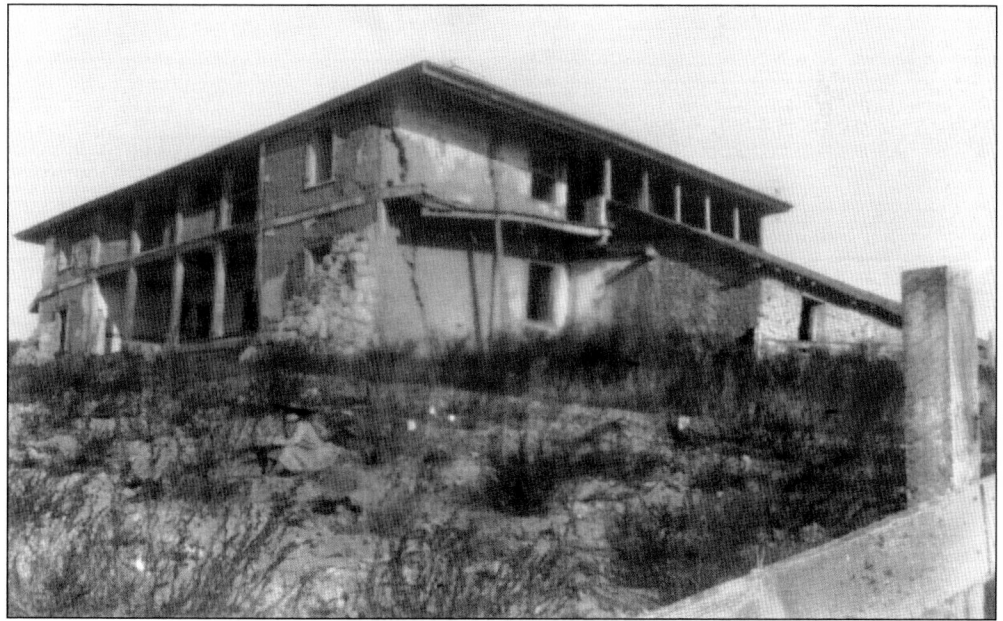

When the Branches first came to the rancho, they lived in a small cabin near the knoll where this great square adobe was built. An earthquake in 1857 damaged the great adobe beyond repair. It was abandoned in the 1880s and slowly melted into the earth. The little girl in the field is Ormie Paulding, cousin of Ruth Paulding. This photograph was taken in 1895. (PHH.)

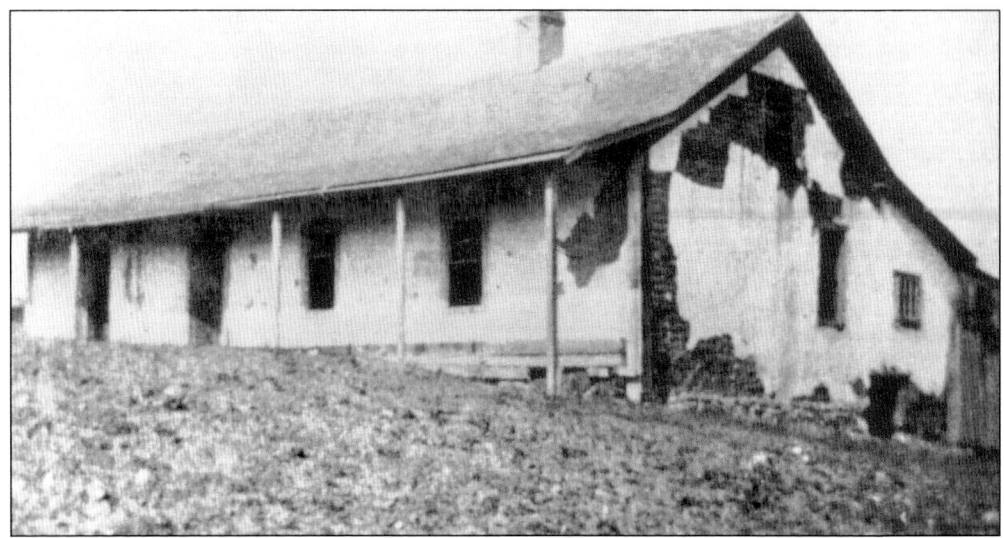

Capt. David Mallagh built this adobe on the stage line where it dipped into the Arroyo Grande Valley, crossed at the least swampy place, and made its way up the side of Newsome Canyon near Pacacho on its way to Casa de Dana. Mallagh may have believed he was building on property he purchased from Isaac Sparks. After much quarreling, Branch paid him to get off the land as he had also paid other squatters. This is probably the adobe where John Price was living when Capt. John Frémont surprised them. Price's Indian workers ran into the thickets of the *monte*. Frémont ordered him to get them out. Price laughed and said quail would be just as easy to find. Frémont went on his way. (SCHS.)

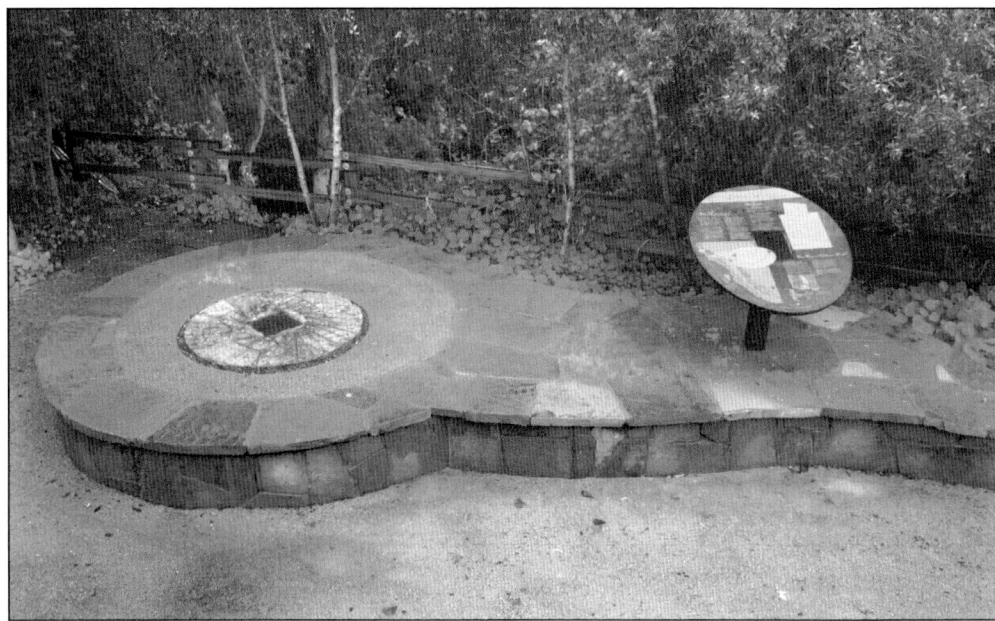

One of the oldest remaining artifacts in the Arroyo Grande Valley is the original millstone transported by the ship *California* from Mexico in 1844 and brought to Branch's Mill in 1846. It was given to Arroyo Grande High School in 1950 and was later acquired by the South County Historical Society. A monument was constructed and dedicated during Harvest Festival in 2008 honoring the first industry of the Arroyo Grande Valley. (GH.)

This drawing depicts Don Francisco Branch of Rancho Santa Manuela overseeing a cartload of hides being delivered to the ship *California*, anchored off Cave Landing, in trade for merchandise brought by the Boston clipper. (Drawing by George Pasion.)

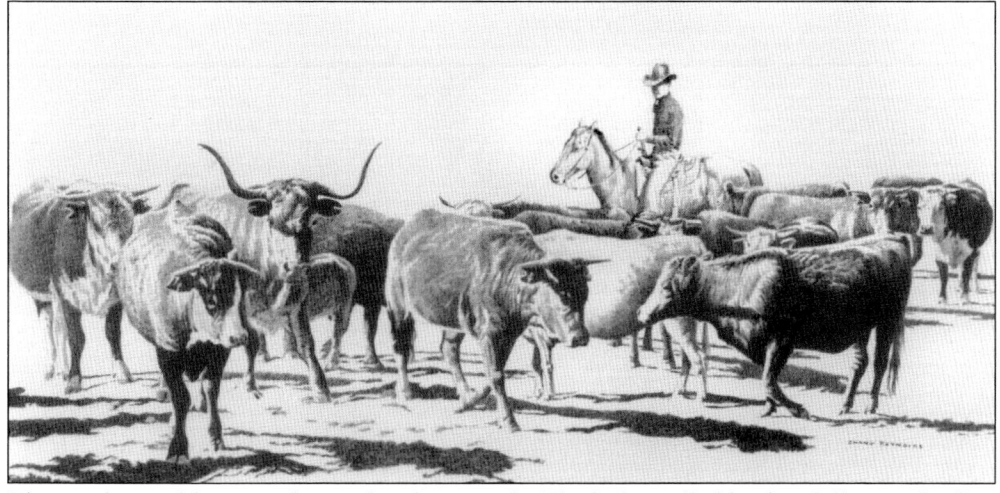

The rancho wealth was tied up in longhorn cattle. The hides, called leather dollars, and tallow were used like cash and paid the bills. (Painting by Chang Reynolds.)

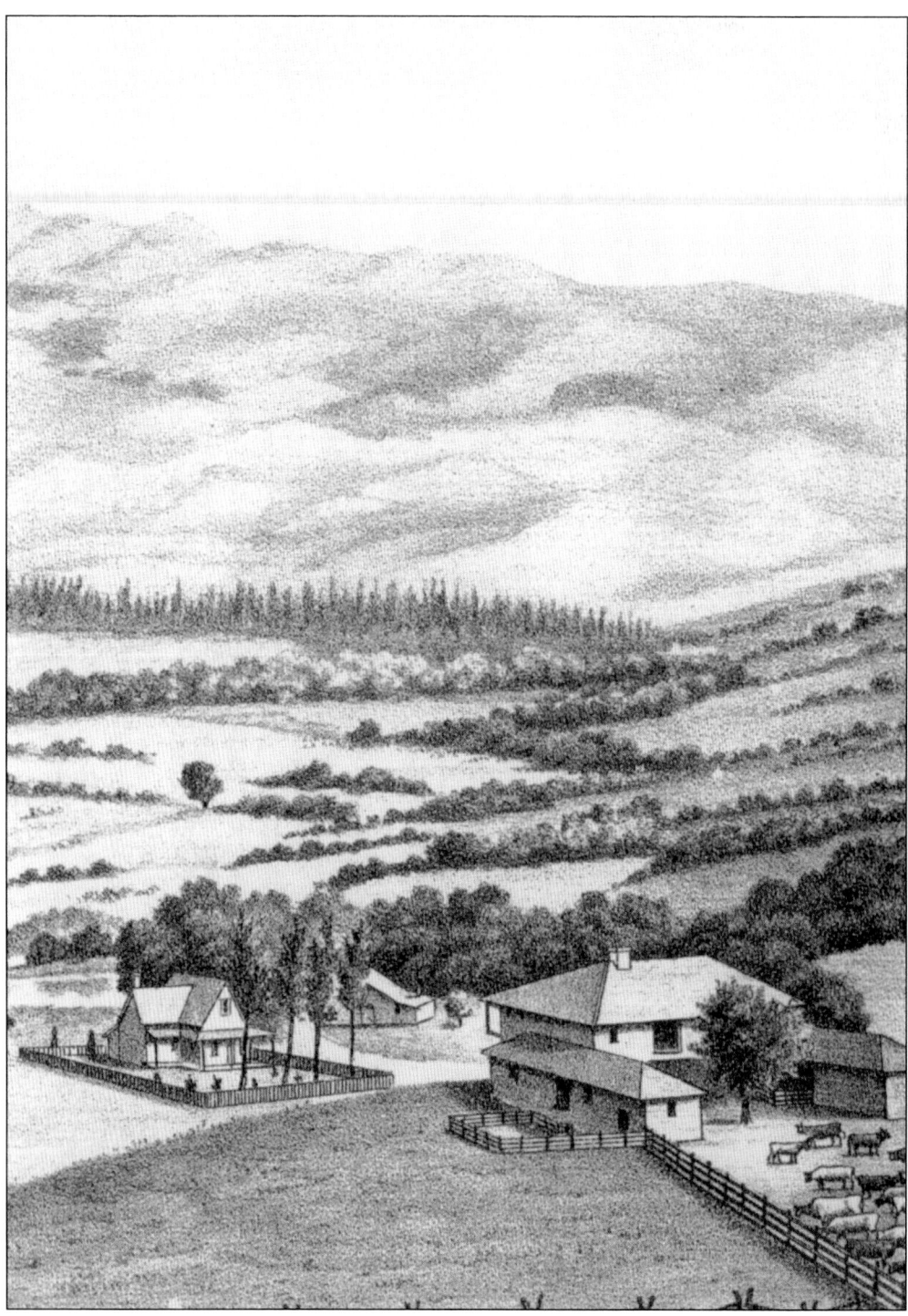

This lithograph is from the 1883 compilation of the history of San Luis Obispo County. It shows the Branch Ranch headquarters after Don Francisco Branch's death, when Don Frederick, the youngest son, took over and built a large redwood house at the base of the hill below the old hacienda. Here Doña Manuela lived out her years. (1883 *History of San Luis Obispo County*.)

Two

THE FOUNDING OF THE TOWN

In the early 1860s, a drought helped to dry up the *monte*, a Spanish word meaning a swamp area overgrown with large sycamores, cottonwoods, and vines. The Arroyo Grande creek had no banks below the Branch Casa but spread out over the valley on its way to the sea. This was home to grizzly bears and mountain lions.

The Branch children were coming of age, marrying, and claiming their heritage. It was time to break up the 40,000-plus acres that was the Santa Manuela–Arroyo Rancho.

Branch petitioned the San Luis Obispo County Board of Supervisors in 1862 to form the political township of Arroyo Grande. In 1867, he laid out the town of Arroyo Grande on high ground near the old Mallagh adobe.

Encarnación Carrillo had married Capt. Thomas W. Robbins six years after her sister Josepha married Capt. William Goodwin Dana. When Encarnación lost the rancho in Santa Barbara after Captain Robbins died, she moved to Nipomo in a house near Casa de Dana. The Branch boys lost no time in paying court to her three daughters.

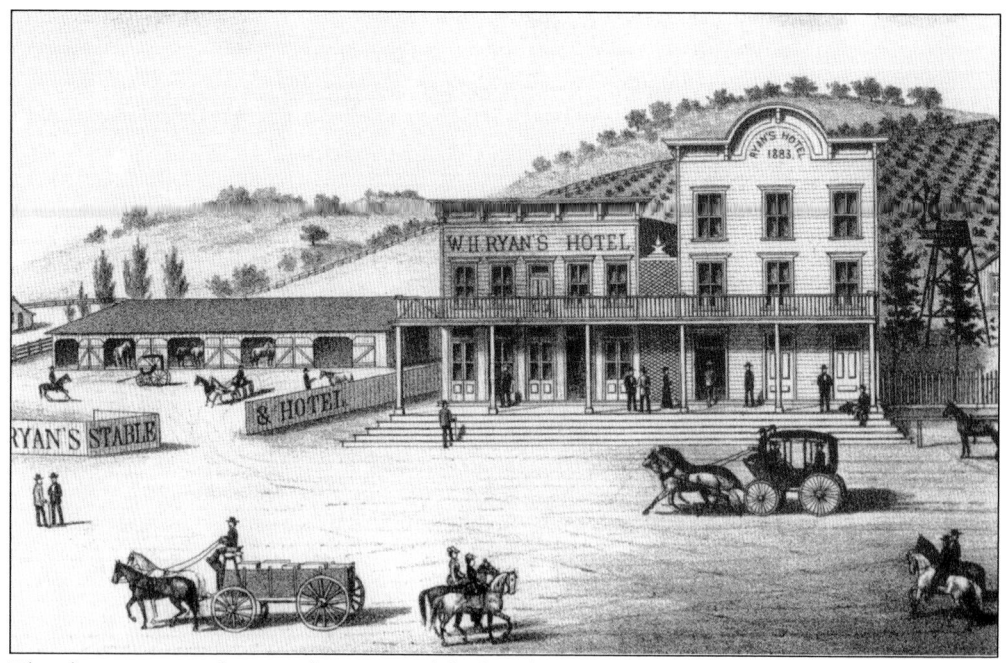

This drawing is a rather overdone view of the hotel and annex built by George Robbins, the son of the late Capt. Thomas Robbins and Encarnación Robbins. In 1873, he sold it to William Ryan. From then on, it was known as the Ryan Hotel. (1883 *History of San Luis Obispo County*.)

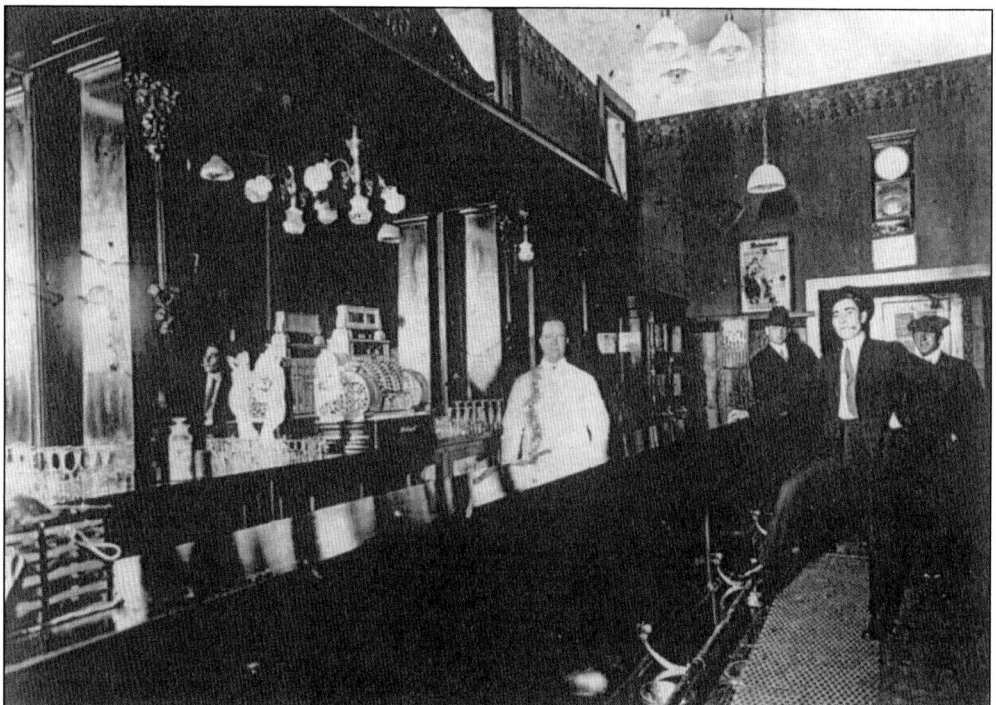

The Ryan Hotel had a dining room and eight bedrooms upstairs. Downstairs, shown here, were the inevitable bar and rooms for salesmen and drummers to display their wares. (Bennett-Loomis Archives.)

George Robbins, the son of Capt. and Señora Robbins, is shown here. He sold his hotel in 1873 to William Ryan, who was here to take the Newsome White Sulfur Springs water cure. George Robbins moved to San Luis Obispo and eventually became the wharfinger of Port Harford, known today as Port San Luis. (SCHS.)

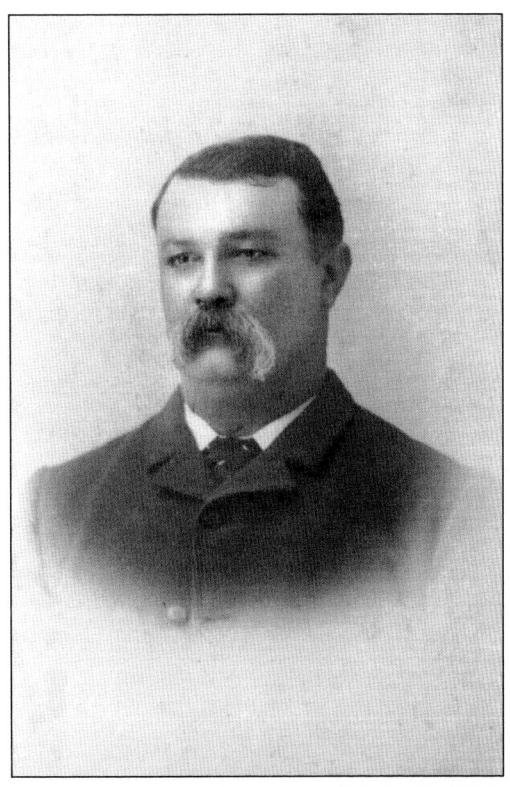

George Robbins built a house near the hotel on the road that was to become Branch Street. He sold to Mr. Donati, who moved it to the present 120 Hart Lane and built a store for his furniture business in its place. (SCHS.)

17

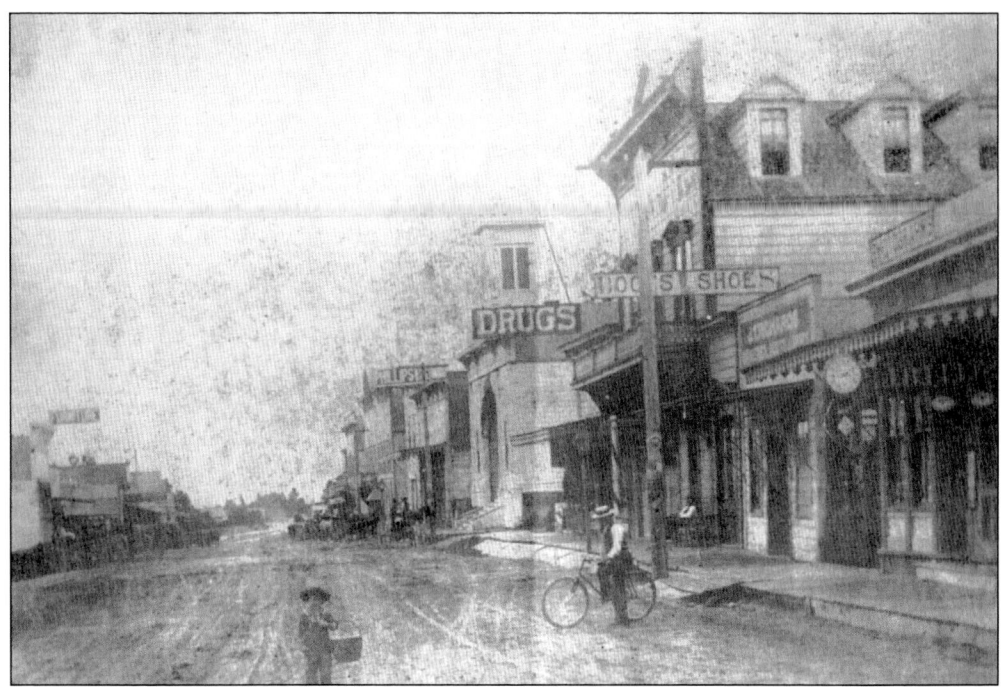
The town of Arroyo Grande began to emerge with several commercial establishments, including a blacksmith shop owned by John Corbett. He later purchased land in the canyon that today bears his name. (SCHS.)

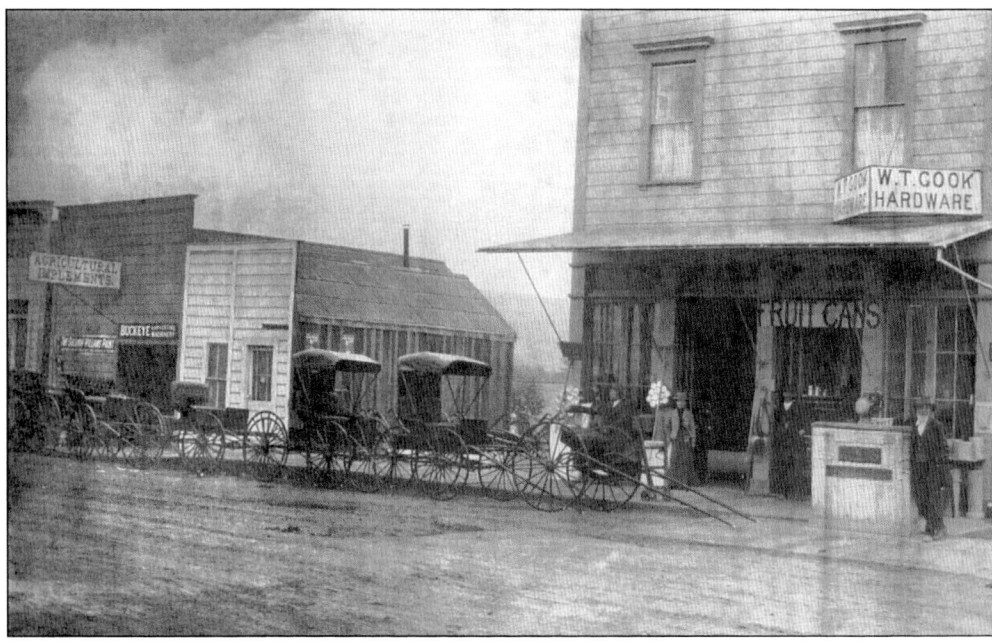
W. T. Cook Hardware store, located on Branch Street, is shown with a good stock of buggies displayed along the street at the beginning of the 20th century. (SCHS.)

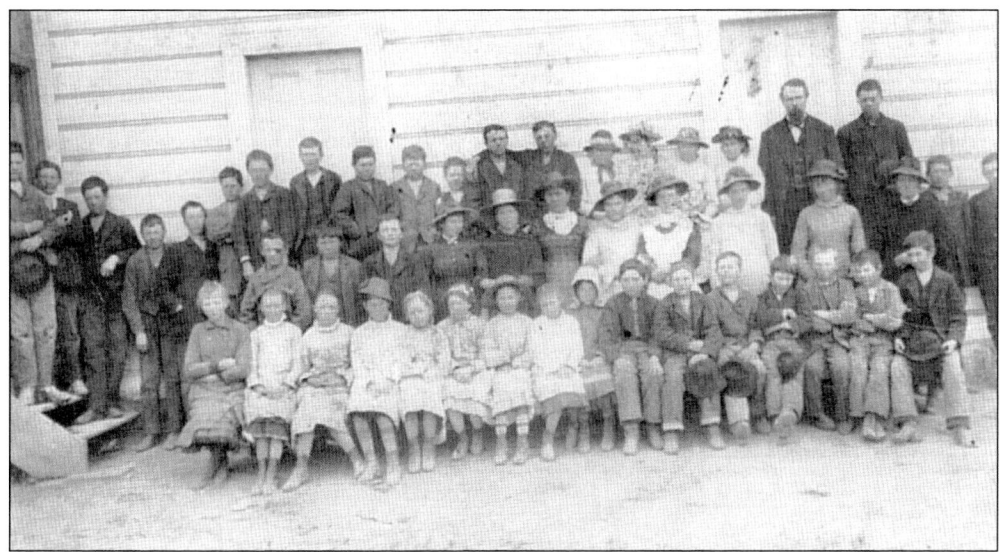

Francisco Branch believed in education. He maintained a tutor in his home as his children grew and also included children of the rancho employees and the Price children from El Pismo. Miss Boulder spent five years as tutor before Peter Forrister, a young lawyer, took over. The picture shows a group of children standing by the very first school. Three acres was deeded to the town for a school in 1867, and Branch built a structure measuring about 16 feet by 24 feet with four windows and a door. The boys usually exited the schoolhouse by way of the windows, according to George Bakeman, one of the students. This schoolhouse was the first in the township and the only school between San Luis Obispo and Santa Maria. (SCHS.)

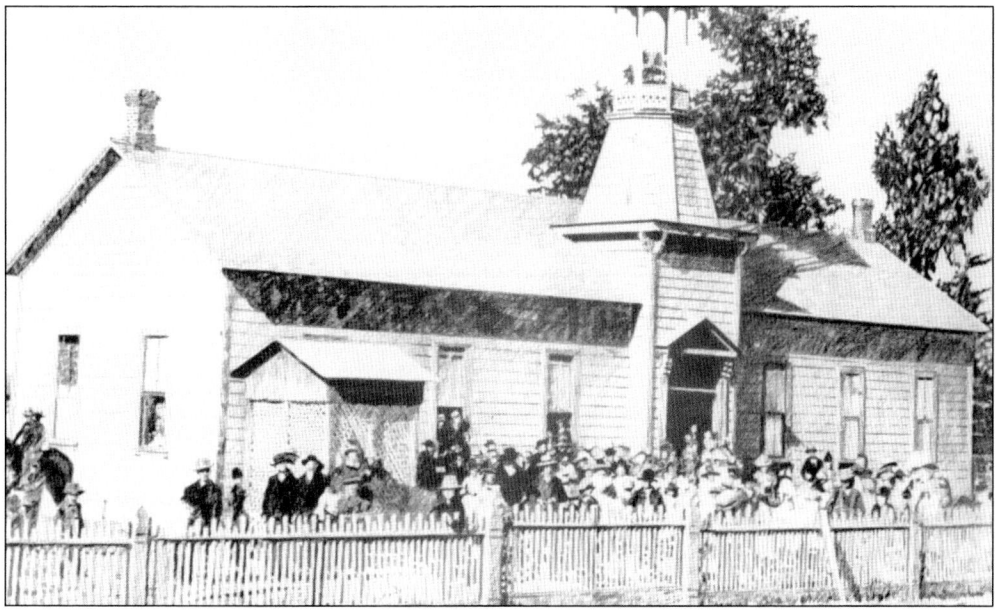

After a shoot-out at the stable near the school where the stagecoaches changed horses, the teacher, W. H. Findley, pronounced it not a safe place for children. It was decided to move the school to an area near what is now known as Traffic Way and Fair Oaks Avenue, the site of the Ford dealer. The fathers of the children got busy and cut the brush and trees and erected this school one room at a time. (Dan Martin.)

Isador Aron and his cousin, Seigfried Alexander, came to Arroyo Grande in the 1890s and opened a mercantile store. Like other merchants in the town, which had no bank, they extended credit to farmers for seed, fertilizer, and other needs. They collected when the crops came in. Even after Aron's death in 1909, Alexander continued the business as Aron and Alexander until he died in 1923. (Both SCHS.)

Grand Midsummer Display
IN COTTON DRESS GOODS,
Such as Ebilenes, Eolines, Gaze de Soie, and Figured Lawns, roidered Waist Patterns, Ladies and Children's Tan Shoes and Lace Hosiery to match.

Groceries, Furniture and Bedding. Ask for Prices.

ARON & ALEXANDER

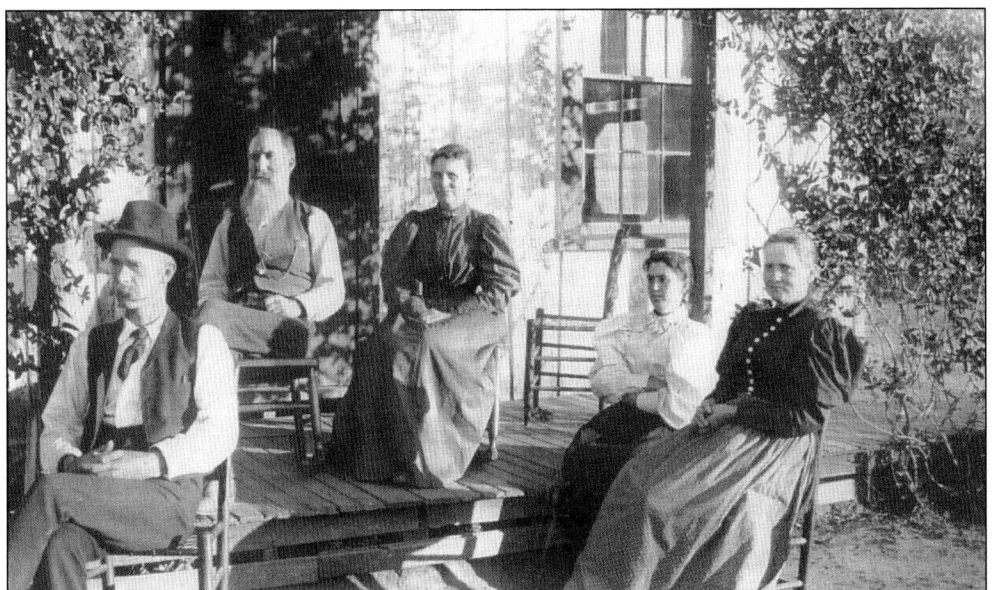

As the immigrants flooded in from the east after the Civil War, Francisco Branch began selling small plots of land. A man could arrange with Branch to clear 5 acres of *monte* (swamp land) and then contract to purchase the land at a negotiated price per acre. Others purchased larger plots, and it was up to the buyer how it was cleared. One such family is shown above. From left to right are John Gilliam, Newton Short, Lou Short, Agnes Gilliam, and Mat Ritchie, all related and citizens of Arroyo Grande shown at the Records' Huasna Ranch about 1890. (Billie Swigert Collection.)

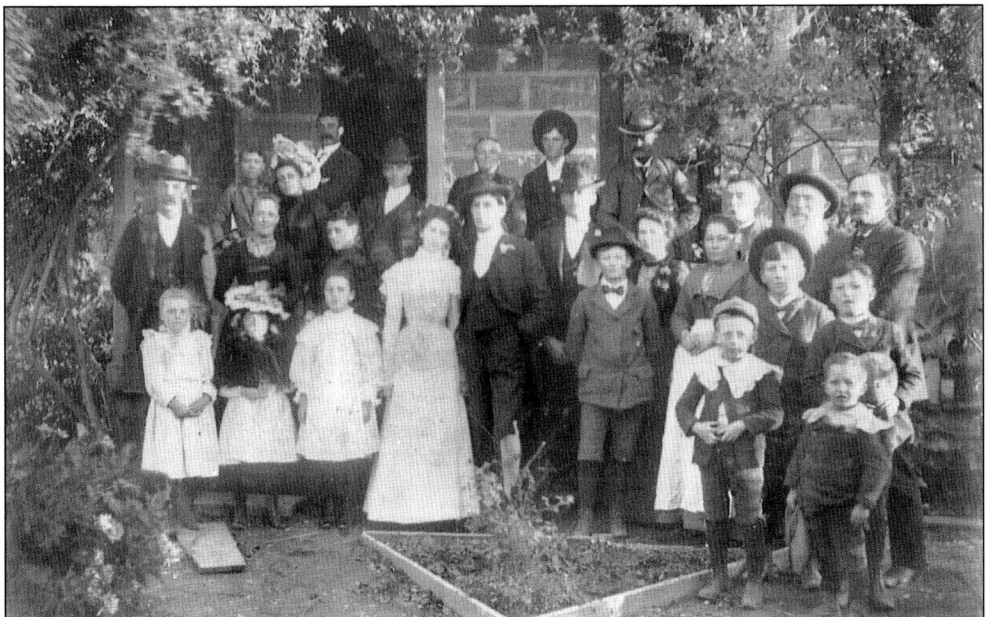

The John Rice stone house in the orchard at 756 Myrtle Street hosted a wedding on November 22, 1899. Mamie Collins, the foster daughter of Mr. and Mrs. J. S. Rice, married Donald McKenzie, the son of the local photographer, in a ceremony performed by Rev. W. B. Bell, who was the pastor of the Methodist Episcopal church. (JH.)

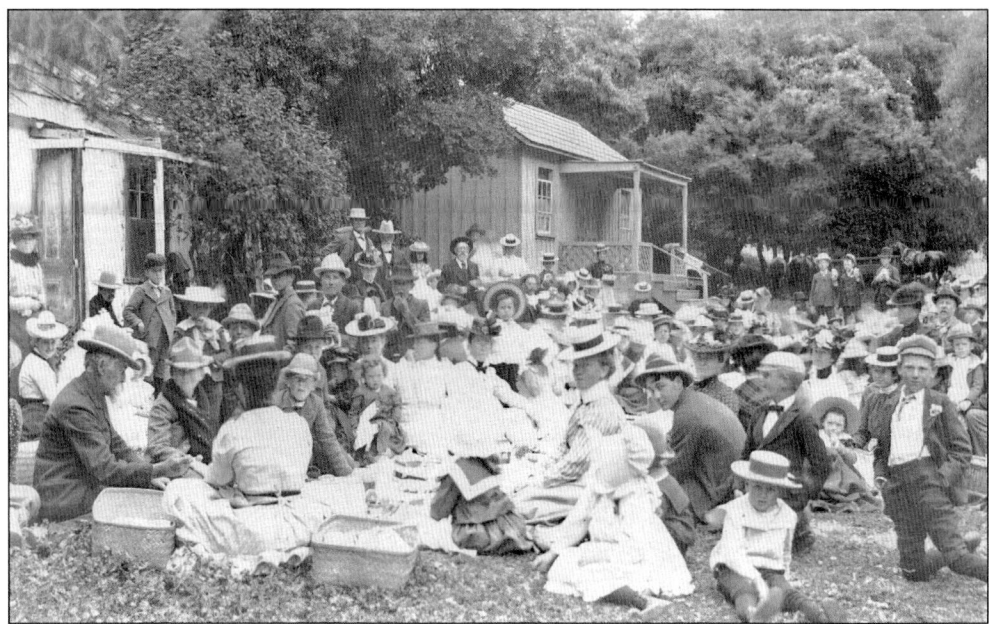

This is a large picnic group at Newsom White Sulfur Springs. Others sought the waters for health reasons. Camping at the springs was free, and the hotel (shown below) and cabins were available for rent. Vegetables, fruits, and hay for horses were plentiful and cheap. (Jack English collection.)

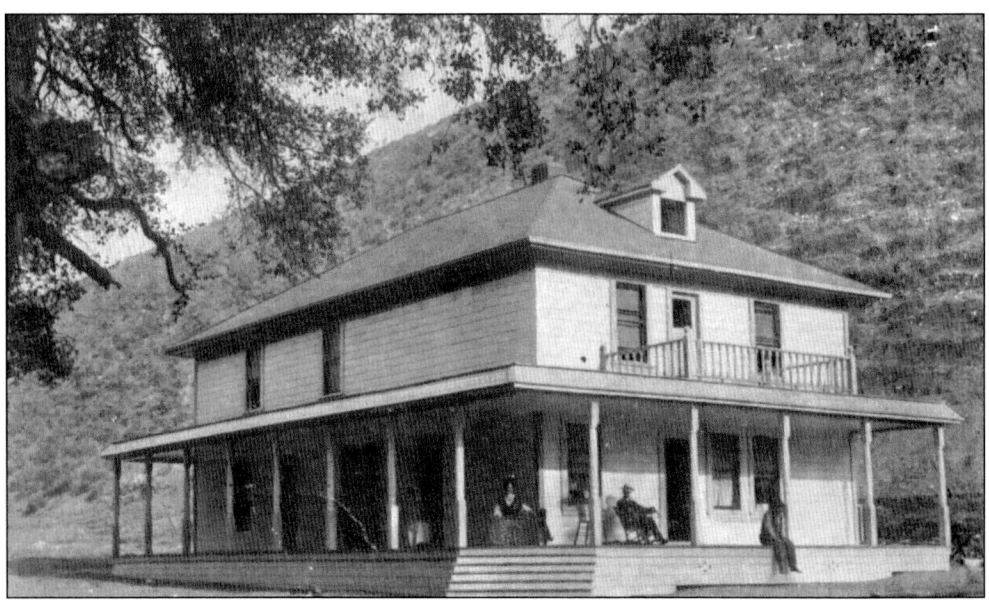

The hotel at Newsom White Sulfur Springs is shown above. (JH.)

The three Jones boys, grandsons of the Branches, are shown on their Huasna Ranch. Years later, when the car replaced the horse, the boys became involved in the oil industry. One of the Jones boys is shown below. (Both Record Family Collection.)

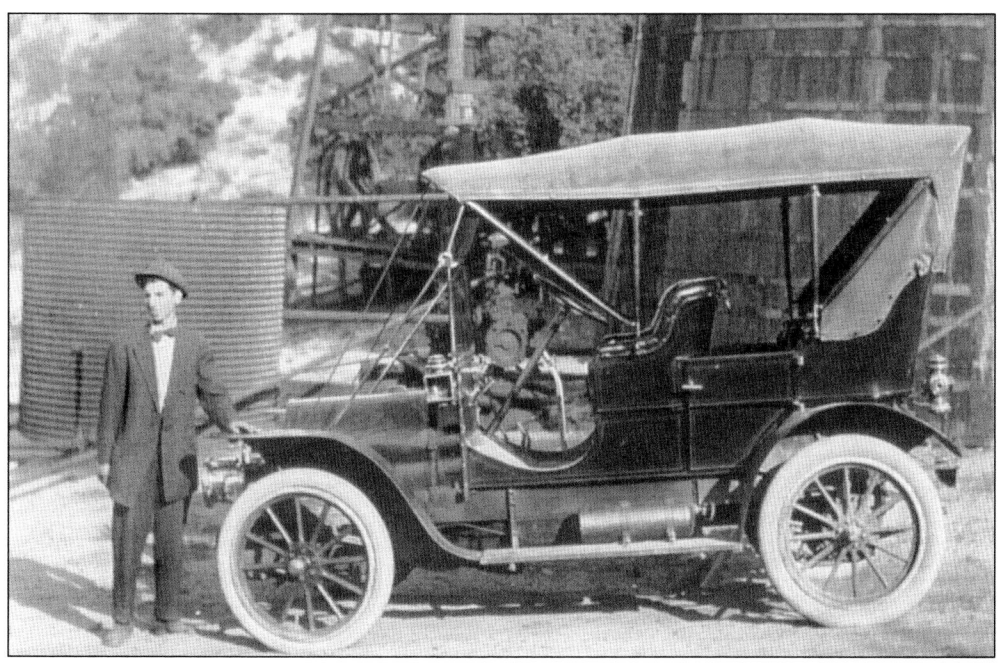

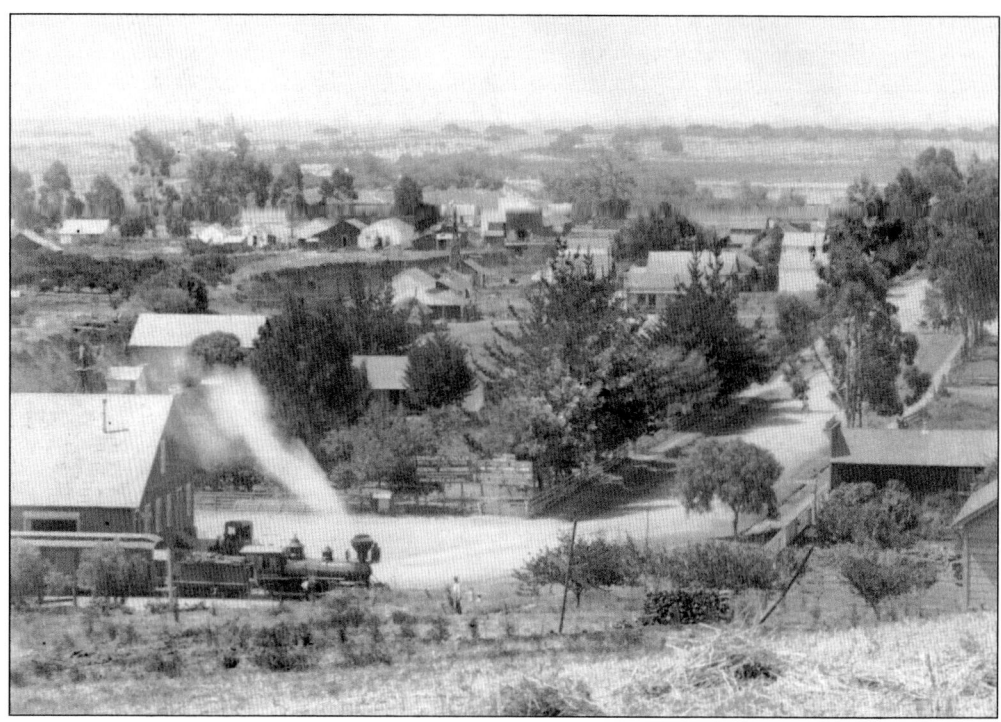

Arroyo Grande lived by the timetable of the little train. It was now possible to go to San Luis Obispo in comfort and much faster than a horse. The one passenger car had red velvet-covered seats and ornate wrought iron adornments. (PHH.)

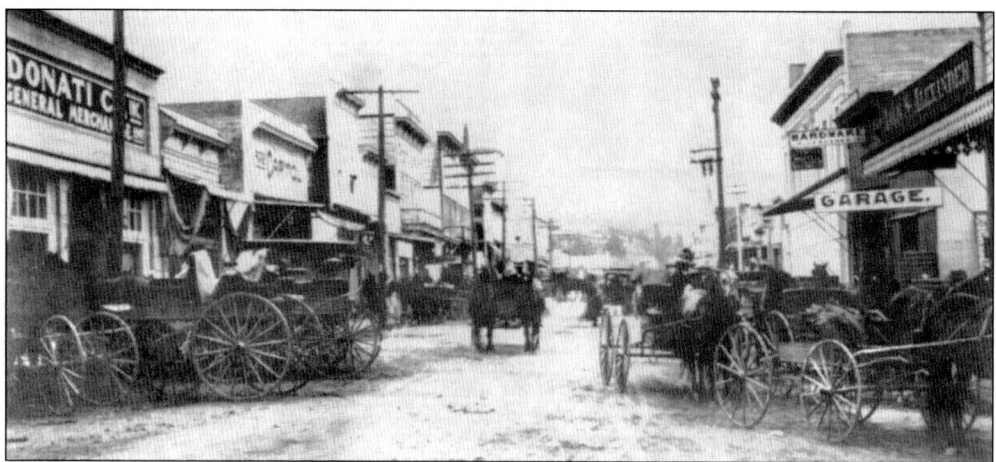

The sleepy little town of Arroyo Grande woke up when the narrow-gauge Pacific Coast Railway arrived in October 1881. The street was lined with wagons carrying the bumper crop of grain ready to be shipped. (SCHS.)

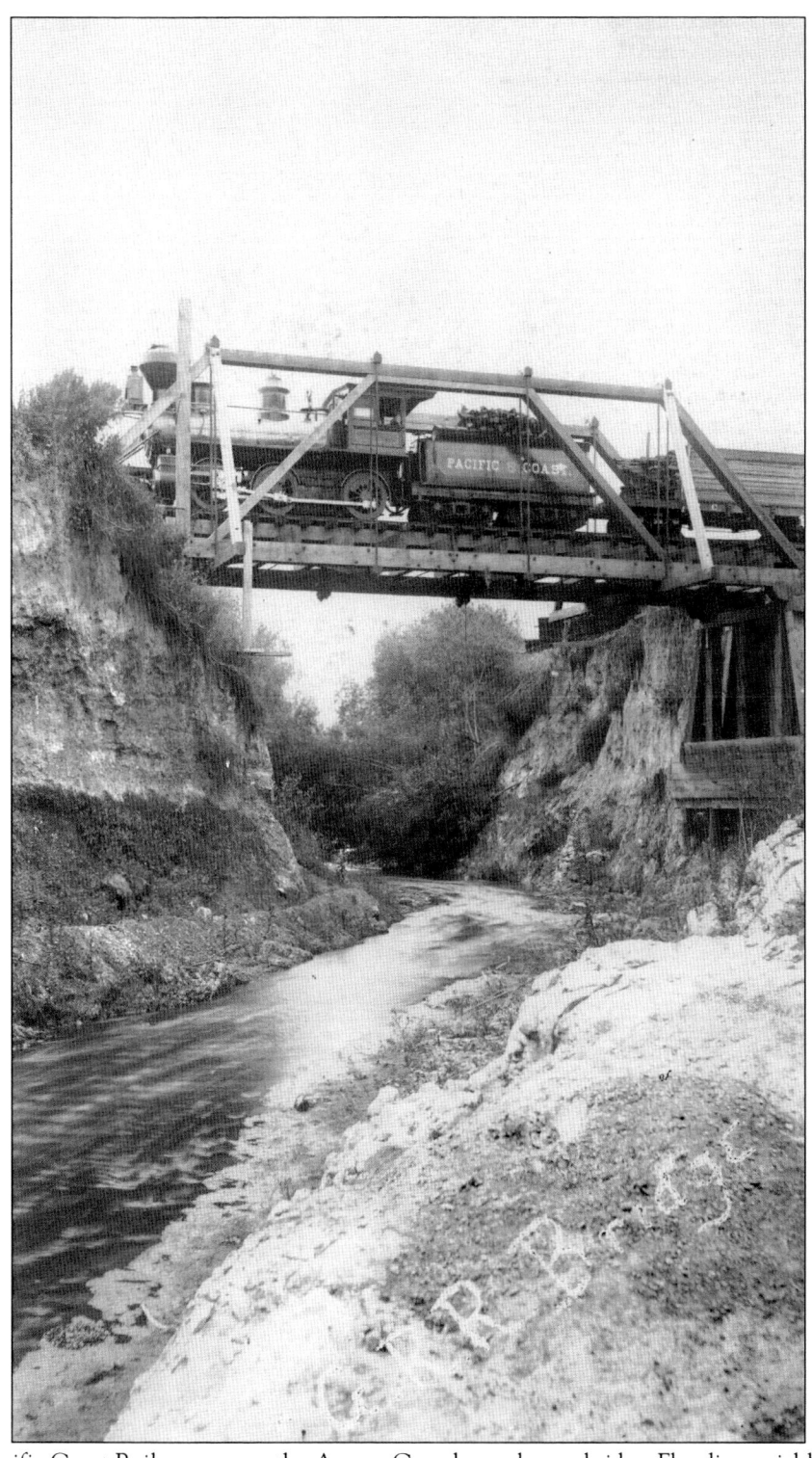
The Pacific Coast Railway crosses the Arroyo Grande creek on a bridge. Flooding quickly made it necessary to replace with a much sturdier bridge. (PHH.)

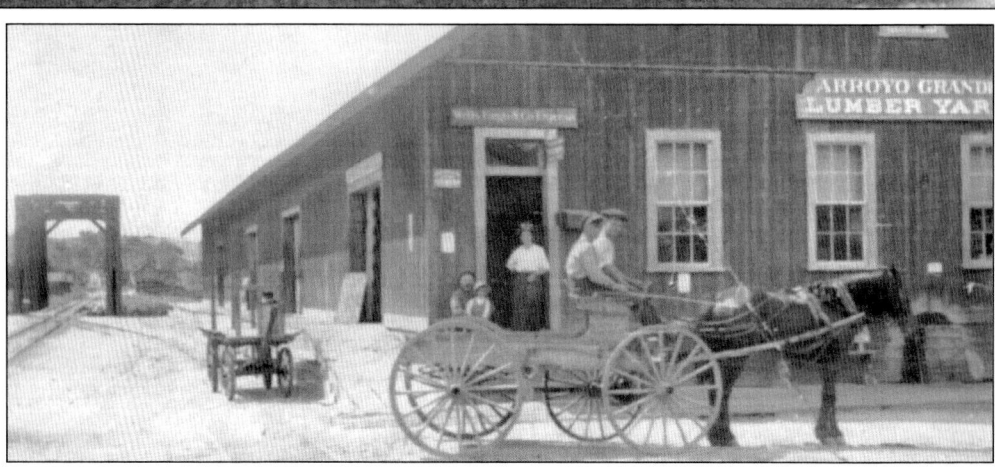

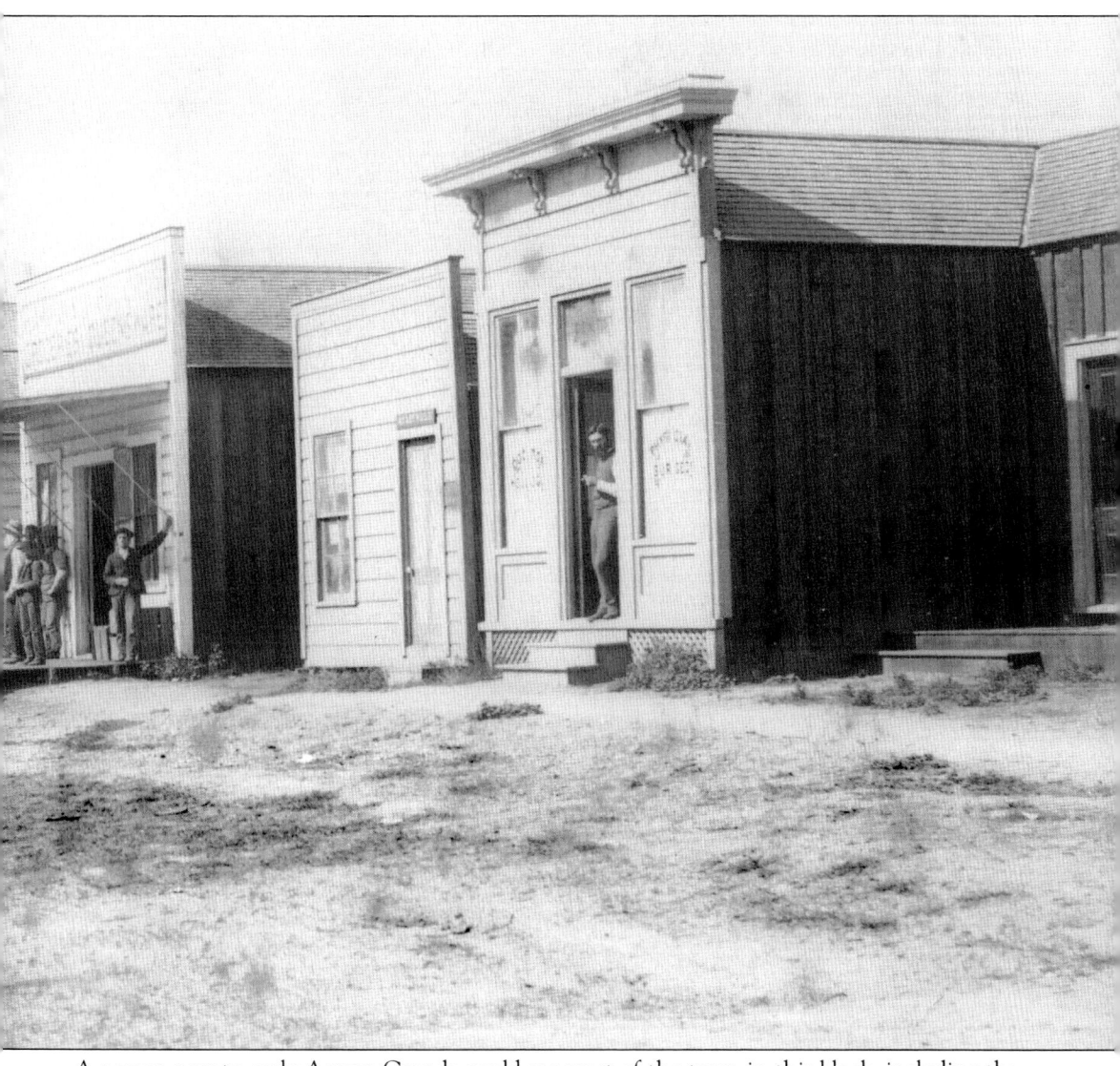

A person new to early Arroyo Grande could see most of the town in this block, including the Good Samaritan Hall. Early organizations promoted brotherly love and mutual assistance. The Good Samaritan Hall, with a decided anti-liquor stance, was used by all the churches and civic organizations and even the school. In the photograph to the left is E. F. Hopkins, father of Ralph Hopkins, seated on the left side of the doorway to the Wells Fargo and Company Express and holding another son, Leslie. He was the town's depot agent upon moving to Arroyo Grande in 1909. Later Hopkins became the city's postmaster, a position he held for eight years until he died in an accident while delivering mail to Pismo Beach. Hopkins's mother, Ella, is standing in the doorway. The horse and buggy riders are H. E. Cox and his son. (Both SCHS.)

Patrick Moore was born in Ireland. He was a rancher and farmer. Although he had no children, he paid for the education of a number of boys and girls. He had been elected to a third term as county supervisor when he died. When other people bragged of their supervisor's accomplishments, people in Arroyo Grande would say, "That's all right, we've got Moore." The Victorian home of Patrick Moore was demolished to construct the freeway through Arroyo Grande. Unfortunately, the freeway route was later slightly changed, which would have allowed the magnificent structure to remain. (Both JH.)

A group gathers in front of the Paulding Drug Store around 1887. Included are Walter Miller, Edward Loomis, Will Paulding (owner), George Ide, and Matt Swall. (PHH.)

Dr. Edwin Paulding, the first permanent doctor in town, fell in love with the Arroyo Grande Valley. He talked an older brother, Ormand Paulding, into coming out from Ohio to practice here. The doctor brothers then talked their pharmacist brother, Will Paulding, into joining them as well. Will opened the first drugstore in town and accommodated the doctors' offices in the rear of the same building. He is shown below in 1882. (PHH.)

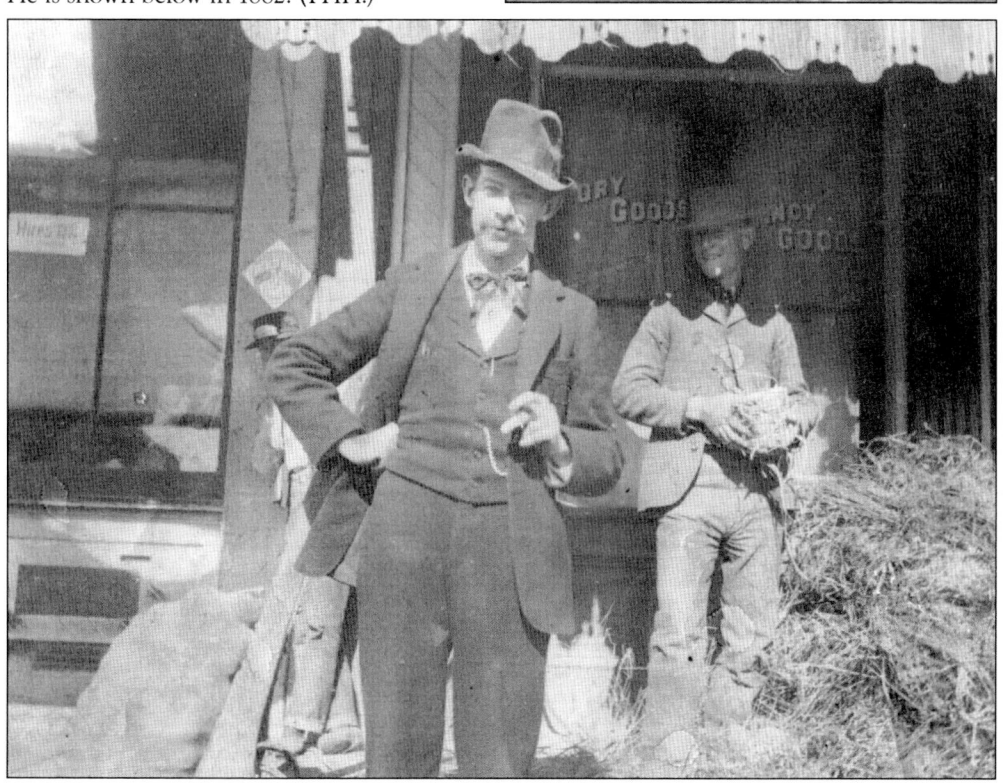

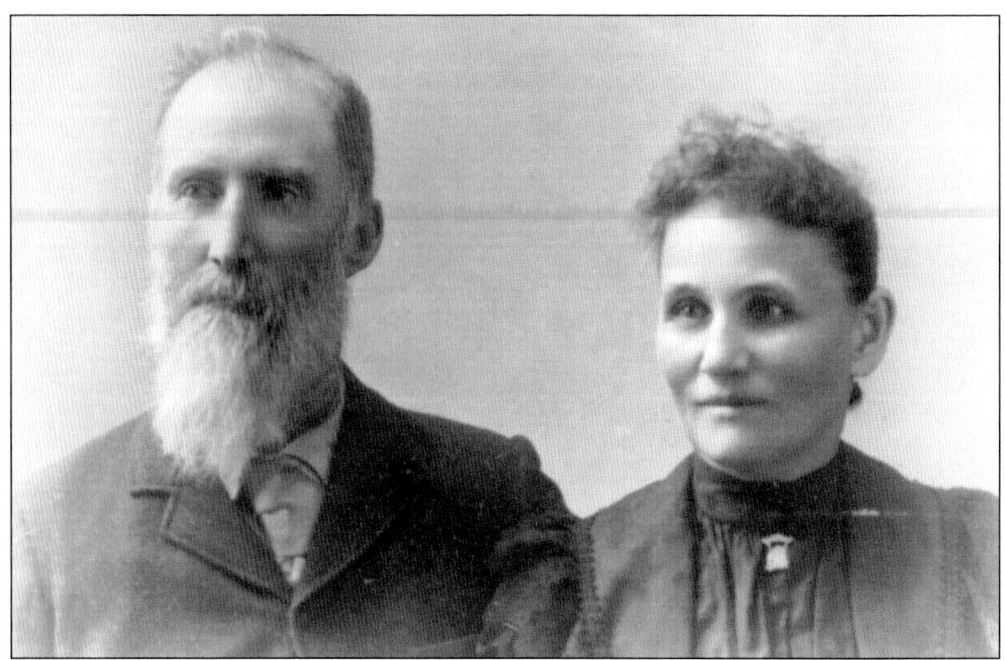

Newton and Louise Short purchased about 10 acres in what was to become the heart of Arroyo Grande and built a home on a street later named for them. (Billie Swigert Collection.)

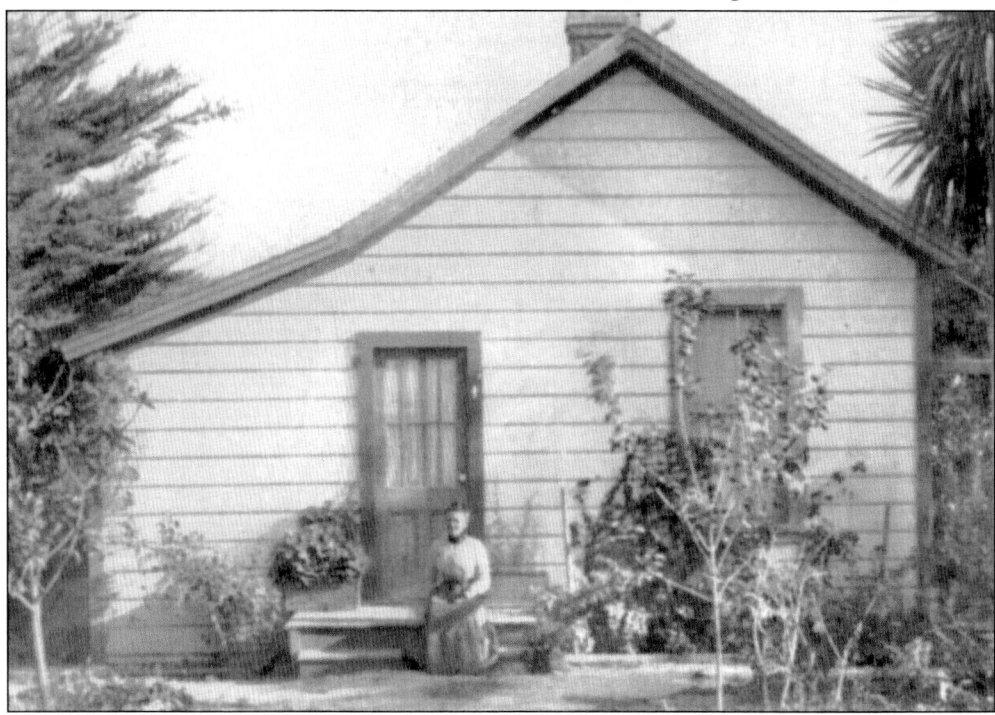

Aunt Lou, as Louise Short was known, helped the family budget by renting out a room. When Clara Edwards, the new school teacher, inquired about a room, she was told, "I'll have no gallivanting around after 10 p.m." Edwards had no such intentions, but neither did she intend to be told what to do, and she went elsewhere in search of a room. (Billie Swigert Collection.)

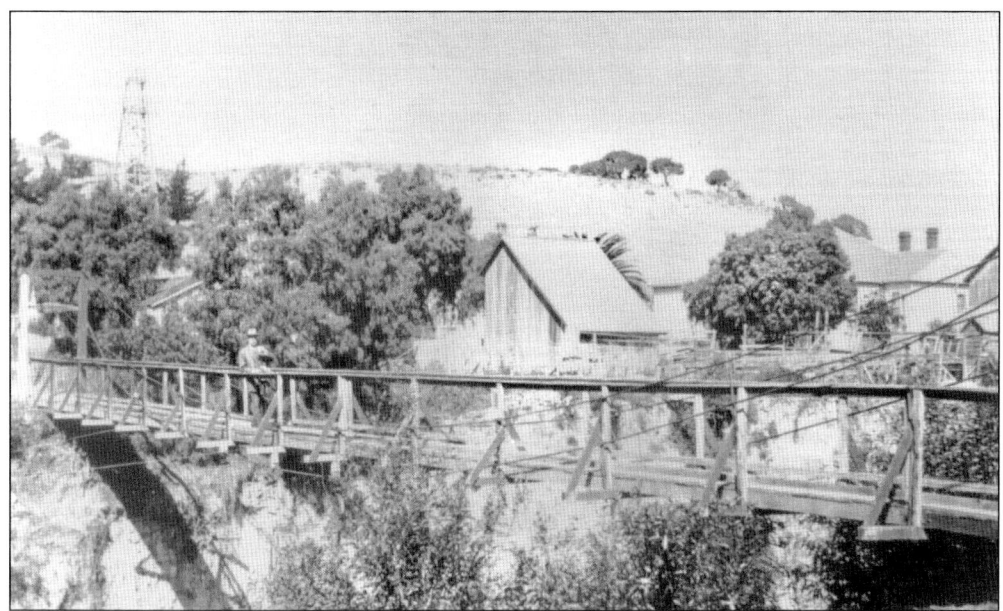

As the land was cleared, the creek sought the bed it occupies now. By the 1890s, flooding made it necessary to put footbridges across the creek, including the one shown about 1909 that had been built by the Shorts. (SCHS.)

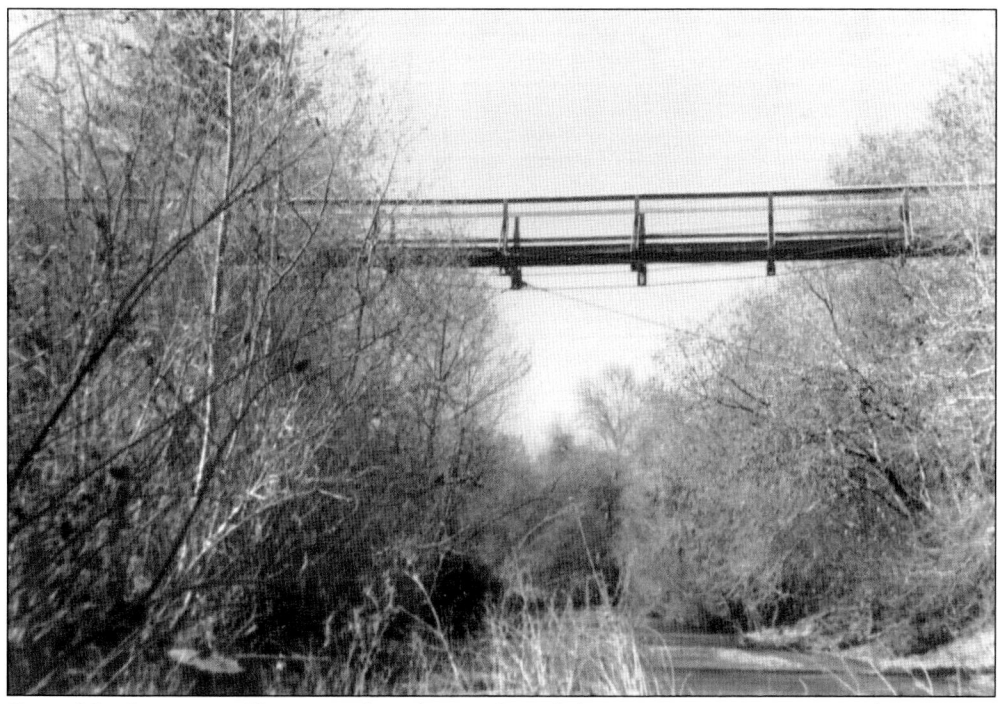

One of the first items of business when Arroyo Grande became a city was to accept the swinging bridge as a gift. By then, the bridge was a regular thoroughfare to town by those living and working on the other side of the creek. The photograph above was taken in November 1956 by Cliff Boswell. (SCHS.)

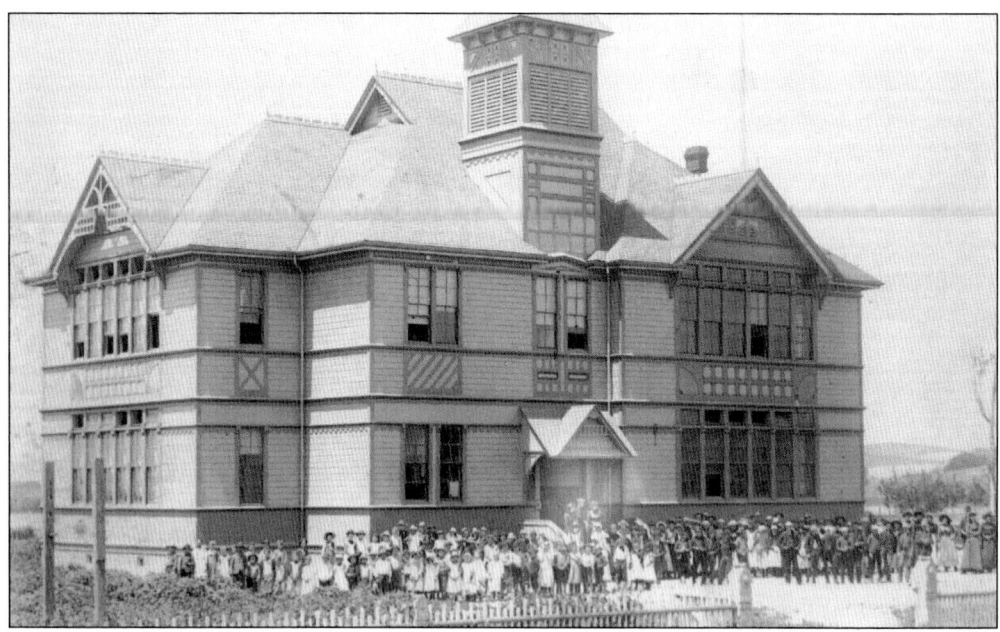

The third Arroyo Grande grammar school was built about 1890 near what is currently the intersection of Traffic Way and Fair Oaks Avenue (the location of the Ford dealership). In December 1899, the school was struck by lightning and burned to the ground. A. F. Parsons was principal at the time. Of course education had to go on, even though "the Lord seemed to be on the side of the kids," said Ruth Paulding. (SCHS.)

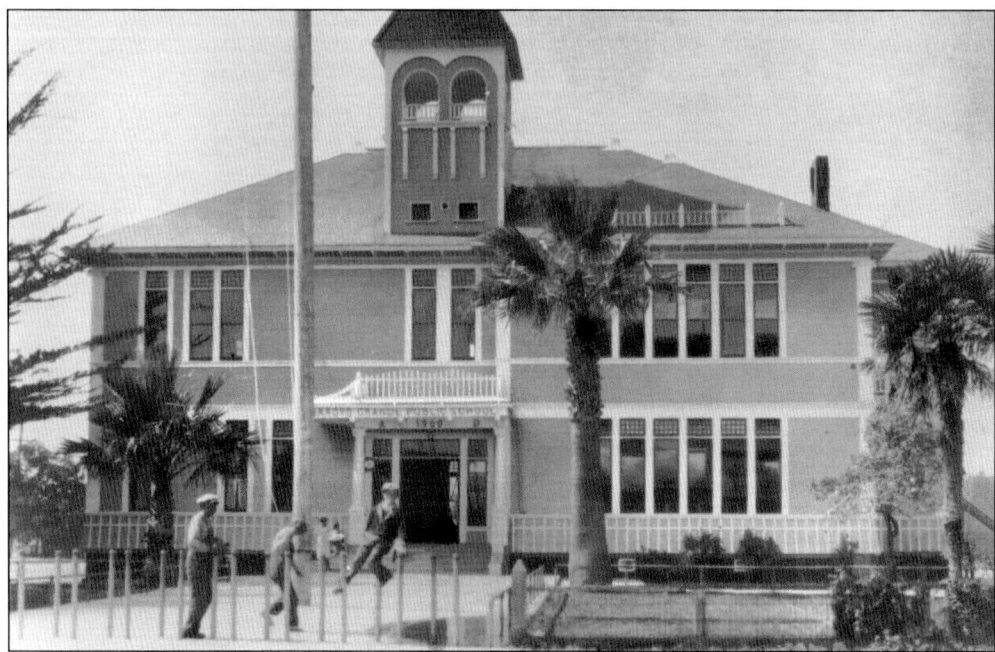

W. B. Bell, a Methodist minister who designed the tabernacle, was asked to prepare plans for a replacement school like the previous with few changes. By August 1900, the school was ready for students. The new building sported single desks that reduced whispering between desk partners. (SCHS.)

Miss Young's second grade class, which included Ruth Paulding, is pictured just before the school burned. They had to use any available space in town until the new school was built. This photograph was taken on June 15, 1898. (PHH.)

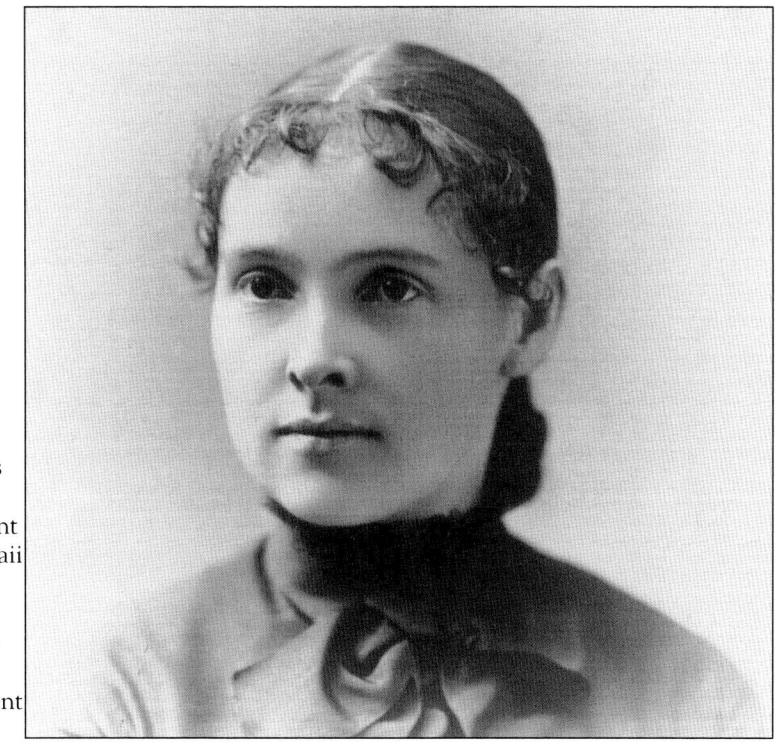

A portrait of Clara Edwards when she graduated from Mills College in 1873 is shown here. She spent several years in Hawaii as a governess for plantation families. In 1883, she came to Arroyo Grande and made it her permanent home. (PHH.)

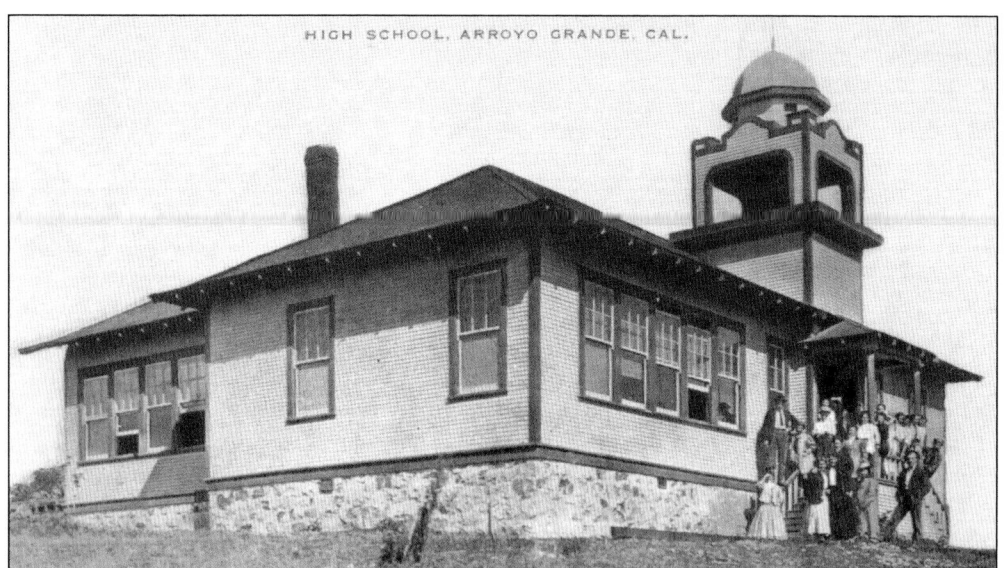

This first high school building was the fourth home for high school students who had used the two grammar school buildings and the Good Samaritan Hall on Branch Street before this 1906 structure was built on Crown Hill. (PHH.)

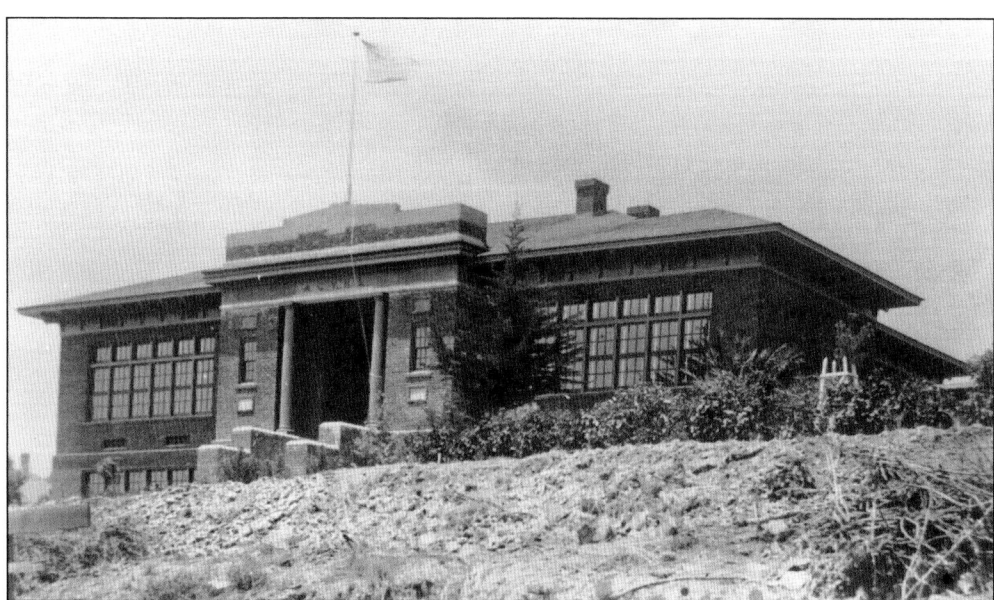

In 1916, this large brick high school replaced the smaller one. A shop building, a tennis court, and hot-air heating were added before the Works Progress Administration (WPA) built a gymnasium in 1939 that is still in use today. (PHH.)

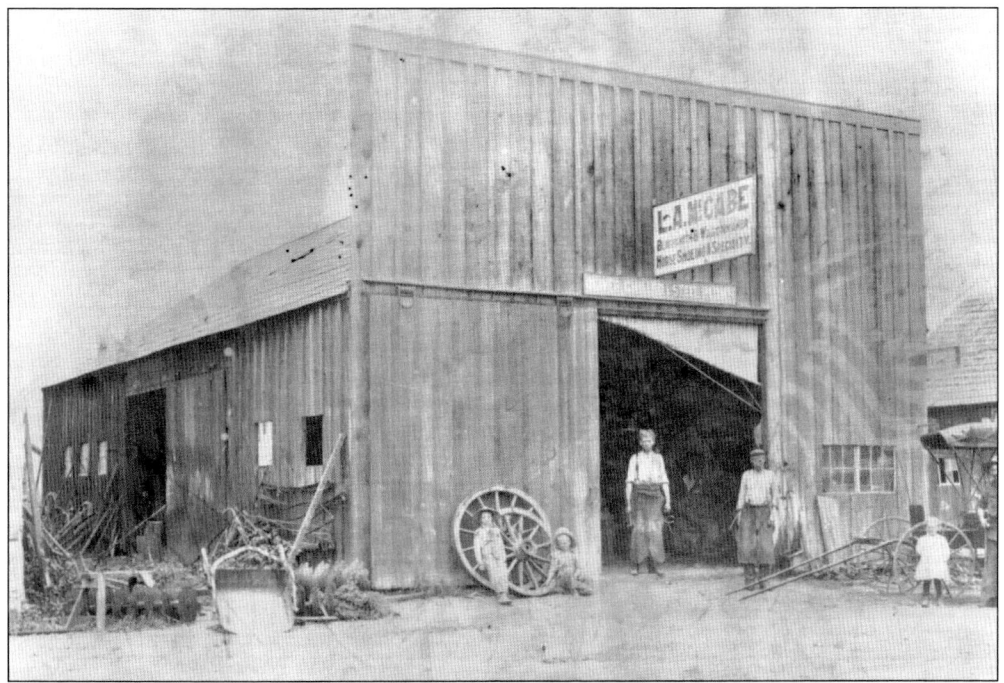

The McCabes operated a blacksmith shop on Bridge Street next to the International Order of Odd Fellows (IOOF) lodge in the early 1900s as well as at other locations throughout the town. (SCHS.)

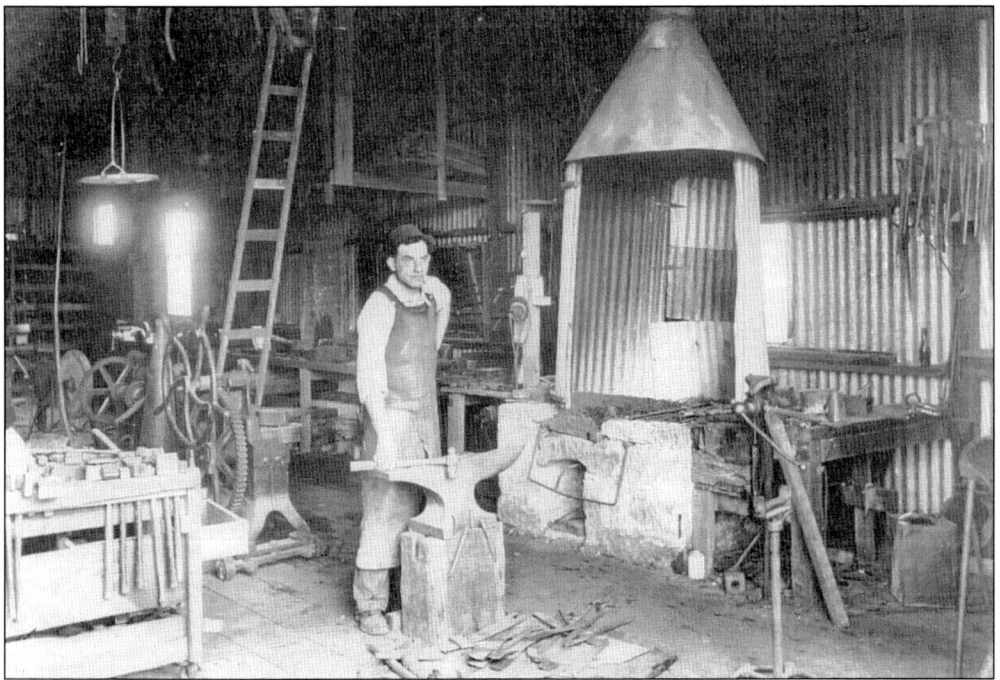

A young Swiss man, Jack Schnyder, bought the established blacksmith shop in 1919. He had no children but adopted the children of the town. His beautiful decorative iron work was highly prized. (Bennett-Loomis Archives.)

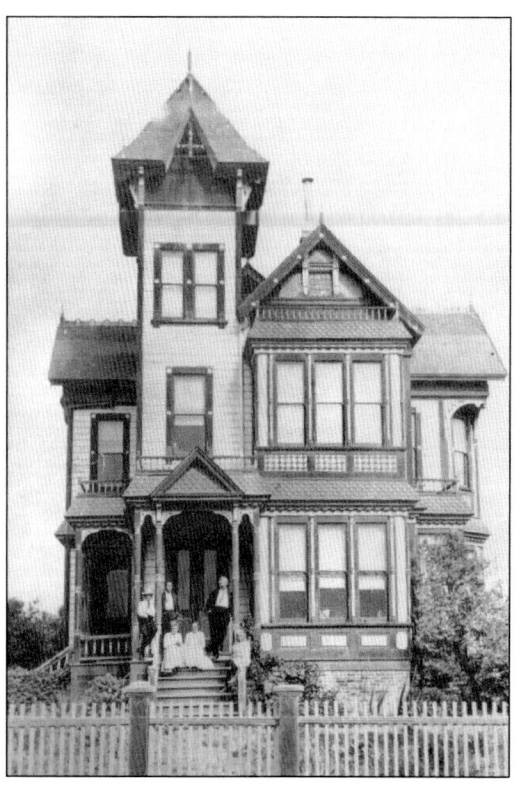

This mansion on Valley Road was built in 1887 by Charles Pitkin. It was bought by Edgar Conrow in 1904. The Conrow family—Edgar and Abby along with their children Clayton, Gwenneth (Fretwell), Mary, and Albert—lived in the mansion for the next 50 years. (Clayton Conrow Collection.)

The Conrow mansion has been maintained in beautiful condition to this day on Valley Road. (SCHS.)

Abby Conrow is seated in front of her piano in the parlor of the mansion. (Clayton Conrow Collection.)

Pearl Cole and Gracia Bello are dressed up on a bicycle built for two in front of the Conrow mansion during Harvest Festival. (SCHS.)

Ben Stewart, shown at left, built the house below at the end of Mason Street in 1902. A friend sent him a postcard of a house in the Carroll Place area of Los Angeles very similar to the one he built. Stewart was the Arroyo Grande city clerk for 25 years. (Both SCHS.)

Dr. Edwin Paulding is shown with his wife, teacher Clara Edwards Paulding, at the Crown Hill home they purchased in 1891. This photograph was taken around 1904 or 1905. The home is currently owned and maintained by the South County Historical Society and is known as the Paulding History House. (PHH.)

Chinese peddler Au Pui walked from Oakland to San Diego every year carrying baskets filled with herbs and small Chinese trinkets. After he unwrapped everything and they "oh and ah'ed," Ruth Paulding said they would buy one item. Doctors were paid "in kind" and most often had little money. He camped in the Pauldings' yard each trip, refusing to sleep indoors. (PHH.)

Stagecoaches like this one came from San Luis Obispo over the Tally Ho Ranch hills and forded the Arroyo Grande creek to the depot on what is now Traffic Way en route to Nipomo and Santa Barbara before 1900. About 1904 or 1905, this coach was used to transport workers to the vegetable fields from Mary King's rooming house in the stone Brisco building. (SCHS.)

Zemaf Bakeman operates a gas-powered water pump west of Arroyo Grande. (SCHS.)

The Bank of Arroyo Grande was established by the Commercial Bank of San Luis Obispo on October 3, 1901. It had been housed at the Ryan Hotel and the building at 112 East Branch. This bank building was constructed in 1906. (SCHS.)

In this interior view of the bank, Joseph S. Gibson and his father, Joseph B. Gibson, are shown. Joseph S. Gibson began as a bookkeeper in 1908. Joseph B. Gibson was already working for the bank. The bank became the Bank of America. (SCHS.)

Schoolteacher Clara Edwards married Dr. Edwin Paulding in 1889. In 1891, they bought the house on Crown Hill. In 1898, Clara went back to work as a teacher to make the house payments. Much was made of her transportation, the bicycle, but she didn't mind, as it got her to Branch School and back each day. (PHH.)

Eva Steele is taking her friends for a drive in her wicker pony cart. She is driving, the person next to her is unidentified, and Elta Parkinson is with Ruth Paulding at the back of the cart. In November 1904, Eva was taking the girls for a drive when the pony was scared by something and suddenly stopped, throwing Elta out on her face. Whirling around, the pony ran over her. Ruth clung bravely to the reins until Mary Lathrop, who was near, reached them and caught the kicking, plunging pony while Clare Phoenix, also nearby, helped carry Elta into the Phoenix house. (The *Herald*.)

Dr. Edwin Paulding was the first permanent doctor in Arroyo Grande. He came through Arroyo Grande on the narrow-gauge railway on his way to see a classmate in Los Alamos in 1883. (PHH.)

Dr. Edwin Paulding is seen contemplating the automobile. When his daughter graduated from college and came home to teach in 1915, she soon bought a car. Dr. Paulding thought if his kid could drive, so could he, but after being pulled from the ditch several times, he went back to the horse, and the family sighed with relief. (PHH.)

Robert English moved uptown on Branch Street with his undertaking business. English (left), Ben Short, and Ben's sister May are pictured at left. English sold to George Kleever in 1915. (SCHS.)

The first undertaker in the town was Beder Wood. As a carpenter, he made coffins, so he also acted as undertaker. R. M. Jersey took over the business from him. In 1895, Ben Short and Robert English acquired the business. By 1902, it was just English, who moved into the bottom floor of the new IOOF hall, operating a furniture store along with the funeral parlor. (Jack English Collection.)

The first cemetery of the area was established by the Branches on their rancho. They chose a quiet canyon near their hacienda for their three small daughters who died from small pox in 1862. Many of the family and friends rest there today. (JH.)

The original IOOF cemetery displays a large mound of flowers on a grave. The cemetery is now maintained by the Arroyo Grande Cemetery District at Halcyon and El Camino Real. Large flower fields were cultivated for seed, making beautiful flowers abundant. (SCHS.)

The International Order of Odd Fellows No. 258 established the cemetery on February 20, 1878. It became the Arroyo Grande District Cemetery in 1918. This picture shows a group in front of the IOOF Hall on Bridge Street forming to march to the cemetery on Decoration Day in 1905. (Clayton Conrow Collection.)

Decoration Day in 1898 is shown here when the Grand Army of the Republic (GAR) held a pageant at the local cemetery. Miss Liberty is pictured with boys to the left and girls to the right probably in red, white, and blue. (SCHS.)

IOOF No. 258 is shown here. The hall was built in 1902 from native sandstone on land donated by Mrs. Elston in 1898. The lodge used the upper stories and rented the ground floor to commercial ventures or as a community center. (Vivian Krug.)

Each summer since organizing in 1884, the Methodists held a tent meeting to energize their membership. John F. Becket gave the church a 15-acre parcel in the canyon behind the church. The 12-sided tabernacle was built in 1897. (Methodist Archives.)

During the summer, vaudeville entertained the campers, followed by a week of revival meetings. Large crowds attended, as shown here. Everyone in town participated, and the Pacific Coast Railway ran extra cars from San Luis Obispo and Santa Maria. (Methodist Archives.)

The Methodist Episcopal congregation formed in 1884 and built a church in 1887. In the 1950s, they moved to Halcyon Road and built a larger church. The old church has had commercial uses but today again houses a religious congregation. (Methodist Archives.)

This cross, made of concrete by Joseph S. Gibson, was dedicated during the Easter sunrise service on April 16, 1933, and was lighted annually during the Christmas and Easter seasons until the weather took its toll in the 1970s. (Methodist Archives.)

In 1905 or 1906, the St. Barnabas Sunday school poses for a photograph. Among the members pictured, in no particular order, are Mr. McKenzie (the Sunday school superintendent), Esther Webb, Gladys Phoenix, Ruth Paulding, May Webb, Porter Clevenger, Eva Steele, Beatrice Whitely, Dorothy Phoenix, Beatrice Phoenix, May Clevenger, George Whitely, Guy Stewart, Chester Steele, Percy Phoenix, Bertha Whitely, Phoebe Poole, Bill Swall, Roy Stewart, Ralph Hall, Benny Drum, Raymond Swall, Ernest Ketchum, organist Mrs. E. L. Paulding (Clara), and violinist Mr. Wright. (PHH.)

This is a view of Arroyo Grande early in the 1900s looking down Mason Street where St. Barnabas Church was built. (SCHS.)

St. Barnabas was the name chosen for the church built on the Episcopal lots on Mason Street. January 1902 saw the first service. Ben Stewart (also the city clerk) was the contractor. It was sold to the Catholic Church and moved to Oceano in 1961. It was renamed St. Francis. (SCHS.)

The little church is all dressed up for Maude Whiteley's wedding. (PHH.)

A group of people from Illinois arrived in 1875. A large part of the valley was covered with forest. The Arroyo Grande creek had to be channeled and the land reclaimed. "But," said one resident, "We missed the sacred shrines, the singing of the old hymns and the churches left behind." The Cumberland Presbyterian Church was founded in 1876 on the land given by Thomas Record on Bridge Street. (Billie Swigert Collection.)

Presbyterian ladies are shown dressed in their Sunday best. In the first row at far right is Earl Swigert. Among those in the second row are Mrs. Bickle, Bonnie Johansen, and Mary Records. In the top row, second to right, is Mrs. Johansen with Mattie Swigert on the far right. (SCHS.)

St. Patrick's Parish was established in 1878 with Fr. Michael Lynch as the first resident pastor. He is buried in the Price Cemetery on West Branch Street. The church was erected in 1886 on Branch Street in Arroyo Grande. For 83 years, it sat beside the Methodist church at 128 West Branch Street before the insurance company deemed it too fragile to insure. Parishioners met in St. Patrick's Hall next to the old church until the new one on Fair Oaks Avenue was built. (SCHS.)

This interior photograph of the church shows the wrought iron altar rail made by Jack Schnyder, the local blacksmith. (SCHS.)

Workers are shown cutting apricots and spreading them out to dry in the sun. These laborers made 10¢ a box for cutting the apricots, making $30 to $40 during the summer. (Clayton Conrow Collection.)

H. G. Sullivan, at left, holds a shovel full of beans that are ready to go through the fanning mill behind him. To prepare the beans, sheets were laid on the ground and the beans spread over them. Horses then walked over the beans to thresh them from the pods. Pictured are, from left to right, Sullivan, J. G. Leach, Charles Adams, Richard Adams, Emma Adams, Mrs. Adams, Earl Leach, and Frank Richards. (SCHS.)

Edgar Conrow and his son Clayton are hauling hay to the barns at their Valley Road farm about 1914. (Clayton Conrow Collection.)

Dr. Edwin L. Paulding was so impressed by Arroyo Grande that he got off the Pacific Coast Railway train and hung out his shingle, sure people who raised pumpkins like that could pay a doctor. (SCHS.)

Joseph S. Gibson, the mayor of Arroyo Grande from 1938 to 1946, stands in front of city hall, which was located across from the current city hall on Branch Street. From left to right are Gibson's son Clair, daughter-in-law Mary, and Gibson dressed for Harvest Festival. The building began its life as the city hall after incorporation in 1911. (City of Arroyo Grande.)

Three

FORMATION OF THE CITY

The July 1, 1911, edition of the *Herald-Recorder* newspaper announced the creation of the City of Arroyo Grande. The headlines notes, "Town Incorporates With a Small but Compact Majority of 2—We Will Celebrate the Nation's and the City's Birthday at one and the Same Time." The paper cited the election results of the ballot initiative to incorporate: every available vote was cast, and at closing time, neither side would have bet 5¢ on the results. The final count indicated 88 votes for incorporation and 86 against. It was reported that the election went off quietly with "there being no rowdyism, drunkenness or any display of ill feeling on either side."

Attorney J. M. Emmert provided the information necessary to complete the incorporation process. He advised that the board of supervisors was to canvass the votes and, upon finding that the majority of votes cast were for the incorporation, should by order enter into the minutes of their meeting a declaration that the territory should be duly incorporated as a municipal corporation and submit a copy of that order to the California Secretary of State. That filing was accomplished on July 10, 1911, marking the official recognition of the City of Arroyo Grande.

Included in the ballot were candidates for office. The first trustees included A. A. Henry, F. E. Bennett, J. W. Gilliam, S. Alexander, and W. H. Dowell. Other successful candidates for office were George Grieb as clerk, B. F. Stewart as treasurer, and C. B. Doty as city marshal. The newly formed city was permitted to levy taxes on property not to exceed 75¢ on each $100 of assessed value. They could also impose a tax upon every male between the ages of 21 and 60 years and an annual street poll tax of $2. In addition, the city could issue licenses for any kind of business, shows, or lawful games.

The Good Samaritan Society, a temperance organization, owned a large and valuable lot on Branch Street with a serviceable building. The trustees announced their willingness to turn it over to the city for use as the first city hall. From these humble beginnings arose the jewel of the California Central Coast, the City of Arroyo Grande.

The city hall and fire department were established on Branch Street in 1911 as shown above. The hall was the old Good Samaritan Hall, built soon after Branch set up the town in 1867. It has been used for many functions, even serving as a high school. (SCHS.)

Henry Lewelling, an early town marshal, was shot and killed in a downtown bar. It is believed that he wore a similar badge to the one pictured here as his symbol of authority. Some time after incorporation, the badge indicated "City Police" but retained the original shape shown at left. (GH.)

Frank Bennett came to Arroyo Grande in 1883. He farmed in the valley and in Oak Park. When Arroyo Grande was incorporated in 1911, he became chairman of the board of trustees. Later the title became mayor, and he continued for 17 years. He managed a cooperative store that led to Bennett's Grocery. His son Ralph continued the family business for 64 years. (Both Bennett-Loomis Archives.)

A tiny one-room concrete jail was built around 1910 on LePoint Street for the county constable. The city council requested authorization to use the branch jail from the county board of supervisors on July 2, 1911, and the jail was later acquired by the City of Arroyo Grande. The property surrounding the old jail was dedicated as the Hoosgow Park in a ceremony on February 14, 1976. (Bennett-Loomis Archives.)

A fire completely destroyed the Ryan Hotel annex on December 26, 1914. The fire also consumed the J. A. Jernigan Building, Kelly's Barber shop, and John Mannin's Shoe store. The ladder wagon still exists in the collection of the Arroyo Grande Volunteer Firefighter's Association. (SCHS.)

This photograph was taken in 1911 from Crown Hill. Beckett's Realty's two-story office is to the left of the flooded Branch Street. Loomis Mill and Feed is on the right. Further down, Mrs. Gray's house had been moved into the street by the Beckett Lake–Tally Ho Creek flooding. (SCHS.)

For years, Beckett Lake in the Tally Ho area filled when it stormed. Once again in January 1914 it broke through, making a channel to the Arroyo Grande creek. No longer Beckett Lake, It now became Tally Ho Creek. (SCHS.)

A group of boys sat atop the Bridge Street Bridge and posed for this photograph in 1920. Those present include Arnold Baker, Clifford Baker, Kenneth McBane, Melbourne "Rocky" Dana, Kenneth Dana, Raleigh "Dilly" Dowell, Vernon "Pat" Wineman, Lloyd Turner, Harold Holt, Malcom "Mack" Swall, Donald "Don" Turner, Lugius "Luke" Waterman, Leo "Buster" McNeil, and Alton "Al" Bardin. (City of Arroyo Grande.)

This image shows people celebrating the reopening of the bridge after a vehicle struck and damaged it in 1990. The truss bridge was designed in 1907 and opened in 1908 on Bridge Street. (Boswell Photograph Collection.)

A view of Branch Street in 1912 includes, from left to right, Mallinson Clothing Store with Mr. Mallinson in front; Adair Hat Store with Celie Adair; F. E. Bennett Store; Langenbeck and Haun Central Meat Market with Louie Haun and Will Langenbeck in front; unidentified; Bink Hixon; and the novelty store with Henry Righetti and Ralph Reinike in front. (Jeanne Frederick and Wilkerson Collections.)

Ole and Florence Gullickson purchased the novelty store run by Ralph Reinike in January 1920 and ran it for the next nine years. The store was right next to Wilkerson's Meat Market and eventually became Wilkerson's Meat Locker, selling to Victor Tarwater. (Gullickson family collection.)

A parade led by a man carrying the American flag is shown between cars lining Branch Street with the furniture store in the background about 1919. (Gullickson family collection.)

In January 1919, Ole and Florence Gullickson drove out to California to visit longtime friend Dr. Harry S. Brown. They were old hunting and fishing buddies. They arrived about the time of the influenza pandemic. Ole drove his friend around to make house calls, allowing the doctor to sleep between visits. Even with the tragic introduction to the area, they liked what they saw and bought a house (above) near Brown's on Bridge Street. (Gullickson family collection.)

Henry Fouch delivered the mail in a buggy with markings that read: "Rural Free Delivery, U.S. Mail, Arroyo Grande." (Jack English collection.)

The Arroyo Grande Postal Service dates back to January 11, 1869. Harvey D. Cornwall also kept the stage station at the edge of Arroyo Grande. The photograph below was taken about 100 years later, when the post office was located on Traffic Way. (*Times-Press-Recorder.*)

Harriett Quimby lived in Arroyo Grande for a while as a child. Her father, William Quimby, visited the IOOF meeting on December 29, 1888, and her mother, Ursula, was a charter member of the Arroyo Grande Rebekahs. Harriett is shown here in the purple flying suit she made famous. (Joan Sullivan drawing.)

Harriett Quimby, a recognized professional journalist, mastered the male-dominated art of flying and achieved immortality by becoming the nation's first licensed aviatrix and the first woman to fly solo across the English Channel. (National Air and Space Museum, Smithsonian Institution, SI 84-18035.)

Donna Hunter and Amelia Earhart stand with W. B. "Bert" Kinner by a plane powered by the engine he invented. Earhart acted as saleslady for Kinner's planes to earn money to buy one. Donna Kinner Hunter lived in Arroyo Grande for a number of years in the 1990s. (Donna Kinner Hunter.)

The Arroyo Grande band led this parade of the Irmandade do Espiritu Santo (I.D.E.S.), which translates to "Brotherhood of the Holy Ghost." The parade led down Branch Street about 1913 to St. Patrick's Church on West Branch. This ceremony dates back to the 18th century, when the royals helped the poor. (SCHS.)

Mrs. Paulding (Clara Edwards), seated on the right, graduated from Mills College for girls in 1873, so it was news when she came back with her daughter Ruth (left) in 1946. She wasn't one to sit around, so she took a history course—ancient, of course, as she'd lived all the rest at 91 years. (PHH.)

Children came from ranches and farms in the area to the Santa Manuela School, shown here in 1921. It became the second school district in the area and was located near the base of the Lopez Lake Dam. (SCHS.)

The Santa Manuela Schoolhouse was built in 1901 on land currently under the base of the Lopez Dam. It served the children of the Lopez Canyon and beyond until 1957. The South County Historical Society obtained the schoolhouse, protecting it before the construction of Lopez Dam and lake. It was moved to a site on the grounds of Paulding Middle School and then to its current location in the Heritage Square area at one end of the swinging bridge in the village of Arroyo Grande. (SCHS.)

This picture is of the Swall and Loomis meat market in 1897, including, from left to right, E. C. Loomis, Matt Swall, and Gilbert Bickmore on Branch Street. (Jeanne Frederick Collection.)

James Wilkinson is pictured in the early years of the Wilkinson Meat Market. (Jeanne Frederick Collection.)

Paul and Leo Wilkinson were brothers who eventually took over the meat market from their parents. The name Wilkinson Meat Market has lasted over 100 years. (Jeanne Frederick Collection.)

The home of James and Clarrisa Wilkinson is seen above. He had farmed in Orcutt, and she had taught school in Creston. They came to Arroyo Grande as a young married couple. (Jeanne Frederick Collection.)

These lovely young ladies are dancing during the Sweet Pea Fair. Rev. L. C. Routzahn gave flowers, mainly sweet peas, to the Methodist church one year and the Presbyterian the next. Beautiful floral arrangements were made each evening during the fair as different groups entertained. (PHH.)

This was part of the display at the Arroyo Grande Sweet Pea Fair. There was much competition to see who could be the most unusual and artistic. (SCHS.)

The Commercial Company was run by Edwin S. "Pop" Whitlock and his family for 58 years. He married Annie Everett of Oceano, and two of his brothers married daughters of the Methodist minister C. W. F. Nelson. Pop and Annie had six sons to help in the store. (Bill Hart.)

This is the interior of the original Commercial Company store about 1917. Although their order is unknown, Ed Whitlock, Walter Harris, and an unidentified man are shown in front of well-stocked shelves. Several people had an interest in the business at first. (Bill Hart.)

The Whitlocks eventually took over the Commercial Company store in Arroyo Grande, shown above. Gaslights hung from the ceiling, and a cracker barrel was located near the cash register. Yardage and ready-to-wear clothing were located on one side and groceries on the other. A large central stairway led to housewares on the second-floor balcony. Fire gutted the building in 1955. It was rebuilt for continued use as J. J.'s Market. (SCHS.)

Three women prominent in the newspaper history of Arroyo Grande are among the members of Col. Harper Post Women's Relief Corps who met to fete their treasurer, Katie Dieffenbacher, in 1907. Dieffenbacher stands third from the right in the front row. She is the mother of Mae Ketchum, seated near the far right, a reporter for the paper since 1901. Jane Shields, who assisted her son-in-law editor W. H. Smith on the paper, is second from left. Mae Clevenger, wife of Steve Clevenger, the founder of the *Herald*, is the small woman to the left of little Frieda Dieffenbacher, the girl in the white dress. (SCHS.)

In October 1887, Steve Clevenger came from Santa Maria and started the *Arroyo Grande Valley Herald*. It was also called just the *Herald*. Clevenger's sense of humor in retelling the news had people rushing down on publishing day to read the latest. (Bennett-Loomis Archives.)

Shown here is the first *Herald* newspaper office on East Branch Street in 1887. (SCHS.)

75

The new *Herald* building was constructed in 1901. It was two stories with the ground floor as the newspaper office and the upstairs as the family living area. It had all-new acetylene gas lighting. Today it has been moved and rebuilt as Chris' Saloon at Tar Springs Ranch. (*Times-Press-Recorder.*)

Virginia and Newell Strother are shown above. Newell was the editor-owner of the *Herald-Recorder* for 20 years. Virginia Strother was the president of the Women's Club of Arroyo Grande at one time. Strother Park is named for both of them for all the things they did for the town they loved. (JH.)

Russell "Hawkshaw" Varian is shown on a campout in 1919 as he celebrates his graduation. Strange things happened when he was around. An example was when the 1919 class conducted the initiation of the 1916 class. It was noted that every time they answered a question, all of the students stood up. Russell had helped wire the bench with electricity. Today he is well known as the founder of the electronics firm Varian Associated in Palo Alto, California. (PHH.)

Pictured is a group of students about 1919 at the Arroyo Grande Union High School with teacher/sponsor Ruth Paulding, who is standing at top left. (PHH.)

77

The 1936 local baseball team is, from left to right, Juzo Ikeda (manager), John Sakamoto, Fred Imoto, Kazuo Ikeda, John Sakamoto, Henry Welze, Harry Kurokawa, Vard Loomis (coach), Hilo

Due to a leg injury, Thornton Lee played a season with the Arizona Globe Bears before going back to the majors. He is fifth from the right in the back row. (SCHS.)

Fuchiwaki, James Nakamura, Seirin Ikeda, Ben Fuchiwaki, Ichiro Ono, and Frank Sakamoto. The team members were identified through Kaz Ikeda. (Ikeda family collection.)

Few people are left who remember the Oceano southpaw Thornton Lee, who played for the Arroyo Grande Union High School in 1923 and, in his last season at Cal Poly, pitched the team to six out of seven triumphs. Thornton pitched for 16 years in the majors, including Cleveland, the Chicago White Sox, and the New York Giants. He then spent 40 years as a scout for the St. Louis Cardinals. (SCHS.)

In 1927, Earl Wood Sr. purchased the mortuary at 139 West Branch Street and the furniture store on East Branch Street from George Kleever. He sold the furniture store when he built the mortuary on Nelson Street in 1938. Earl Wood Jr. and Edith purchased this business in 1945. (Earl Wood family.)

This 50th-wedding anniversary photograph was taken on June 14, 1944. From left to right are Ray L. Wood, Earl W. Wood, Anna K. Wood, Earl Wood Sr., and Beth Wood Conrad. (Earl Wood family.)

Oil workers tend the oil well off Huasna Road near Crown Hill in 1902. It never amounted to anything until it fouled up Bob Shigenaka's yard in the 1990s. Then it was pronounced a real nuisance. (SCHS.)

An early photograph shows where Certified Freight Lines was located on Branch Street in Arroyo Grande before it moved to Oceano in 1984. Bank of America now occupies the site. (Certified Freight Lines.)

An aerial photograph published in the October 1959 *Hospital Profile* shows the beginning of the freeway in mid-town. As far back as March 1950, the state highway department had revealed plans for a four-lane freeway through Arroyo Grande. (SCHS.)

Four

OVER THE FREEWAY AND INTO THE COUNTRY

By August 1949, the Arroyo Grande City Council began exploring the effects of joining Fair Oaks district to the City of Arroyo Grande. A number of merchants had already moved their base of operation to Fair Oaks. A Fair Oaks Civic Association had been organized. The phone company bought lots at Cornwall Avenue and Halcyon Road as the site for their expanded office with the phone system on its way to automation. In September, bids were called for the new high school to be built on Valley Road out in the country.

A hospital was being discussed by a growing medical community. The need for a city hall was on the front burner. The house across the street from the existing hall was being considered. The merchants didn't want it to leave Branch Street.

In March 1950, the state highway department revealed its plan for a four-lane highway through Arroyo Grande. It would be another eight years before this became a reality. First Grand Avenue would need to connect to Branch Street.

With the development of Lopez Lake (dedicated in 1968), other amenities were discussed, such as sewers for all. During this period, Arroyo Grande was headed by a female mayor, Jane Thompson, the first here and among the minority statewide. The Methodists left their small church on Branch Street and joined the telephone company on Halcyon Road. The newspaper left its small building for a larger complex on Grand Avenue that included Mid-State Bank.

1949

In 1949, the Fair Oaks area, out in the country, was waking up. The cemetery at Halcyon and the highway occupied the largest acreage. A theatre had been built on Grand Avenue, and near it was a large building that housed a number of different retail businesses. They were still about 10 years away from housing tracts. (City of Arroyo Grande.)

An aerial view of the community is seen in 1975 on a postcard reading "Arroyo Grande, California. Situated on the central California Coast in a mild climate area and is basically ranch and farm oriented. Entrance to popular Lopez Lake and famous Oceano beach known for its sand dunes and clamming. Much of California produce is grown in this general area." (Gillco Sales, Lompoc, California.)

Mid-State Bank opened in 1961 in this rented building on Grand Avenue in the Fair Oaks district of Arroyo Grande. Its mission as a local bank was to serve the Central Coast. Founding Mid-State Bank officers were Albert Maguire, Carrol Pruett, Walter Filer, Leo Brisco, Marvin Andrews, Marvin Hartwig, and Clifford Clark. (Carrol Pruett collection.)

By September 1949, the city council was discussing the necessity for a hospital for the area. In October 1960, the site for the hospital was chosen on Halcyon Road. Doctors Wical, Bailey, Cookson, and Scott said they expected a spring 1961 opening. The Arroyo Grande Community Hospital opened its doors in 1962. (*Times-Press-Recorder.*)

Leo Brisco recognized the future for the automobile. He opened his first service station in the 1920s at Bridge Street and Nelson Street; he also manufactured batteries and built roads. (Howard Mankins.)

In 1927, Leo Brisco built a new service station and opened a Chevrolet automobile agency. His wife's deluxe sedan was purchased wholesale at $640. They both drove school buses, and Leo began getting equipment together to do construction jobs. (Howard Mankins.)

Leo Brisco saw beyond the horizons. In the 1930s, he got together enough equipment to bid on road construction jobs. He did much of the paving of Big Sur and San Simeon as well as some paving in the Arroyo Grande Valley. Additionally, he extended the runways at the Santa Maria Airport just before World War II. The equipment was housed at Brisco Road and El Camino Real. (Howard Mankins.)

In later years, as a result of work he did improving the harbor, Brisco became the passionate president of the newly formed Port of San Luis Harbor District. He was a founder and active board member of Mid-State Bank. (Howard Mankins.)

Leo Brisco could always seize the moment. The material for the buildings he first erected was mainly from a Canadian lumber ship that went aground at the beach. After World War II, he bought army buildings and demolished them. The army used scarce high-grade lumber. That is how he got into the lumber business. As Brisco reached his 90s, he turned the business over to two of his nephews. Today Brisco Mill and Lumber still serves the public but is run by the Howard Mankins family. (Howard Mankins.)

Nip N' Tuck Liquors no. 2 is shown above; no. 1 was located in Grover City. The no. 2 store was at the corner of Elm Street and Grand Avenue at Brisco Road in the Fair Oaks district according to the newspaper advertisement in 1959. Owned by Don Archer and Marion Ashley, it was the newest in self-service and boasted plenty of parking. The year after North Elm Street was developed, Elm Street was misaligned and had to jog as it passed the parking lot. Future banks were forced to use the rear lot for parking. (*Times-Press-Recorder.*)

Young's Giant Food at Oak Park Boulevard and Grand Avenue brought the first supermarket to the area. (*Times-Press-Recorder.*)

Farm and Home supply opened in February 1961, becoming another business in the newly annexed Fair Oaks area. This new business faced the Nip N' Tuck Liquor Store across Grand Avenue, new the year before. Here one could buy lumber, paint, and other building necessities. (*Times-Press-Recorder.*)

The old school site was eventually the home of the Ford agency on Traffic Way. The dealers at the location include Guy Palmer, Maury Brennan, Vic Pace, and the Mullaheys. This 1950 photograph shows the Mehlschau brothers from left to right—Peter, George, Andrew, and Chris—proud owners of new Ford pickups. (Mullahey Ford.)

Remaining at the intersection of Fair Oaks Avenue and Traffic Way, the Ford dealership is owned and operated by the Mullaheys, as seen in this 2009 photograph. (GH.)

An ingenious farm worker stacks boxes as high as possible to make his labor as efficient as possible. (Clayton Conrow Collection.)

Gabe de Leon was president of the Filipino community but also a member of many advisory commissions. He also farmed for 40 years. Gabe was elected to the city council and in 1976 was appointed mayor of Arroyo Grande. In October 1976, Gabe was honored by the Philippine consul generals from both San Francisco and Los Angeles for being the first Filipino mayor of an American city as well as his other accomplishments. (Michael de Leon.)

A worker at the Tomooka farm is shown between the tall peas that are still grown in the region. (Tomooka family.)

The house at the Porter Ranch was built in 1898. The land was given to Isaac Sparks in 1843. When he died in 1867, he left it to his three daughters. The eldest was Rosa Sparks. Porter's descendants still ranch the spread. It remains the oldest ranch in the area operated by the descendants of the original family. (Porter Ranch Company.)

While better known for their cattle business, the Porter Ranch Company also raised pigs and would herd them to market in a fashion similar to cattle. It was a gala day when Porter Ranch brought pigs or cattle through Arroyo Grande on their way to the railroad in Oceano. (Porter Ranch Company.)

The Gularte family is shown picking strawberries in 1927 on Huasna Road beyond the Portuguese Hall on East Lopez Drive. From left to right are Barbara (Dutra), Mary (Martin), mother Clara, father Joe, Clara (Rose), Ann (Silva), Rosie (Winslow), and Edwina (Leinardi). (Ann Silva Collection.)

Agriculture remains important to the community, including the strawberries in the valley that are picked by workers. (Kadama Collection.)

These tall markers once graced the graves of John Michael Price and Maria Andrea Price. The markers read: "John Michael Price, in loving memory, born in Bristol, England September 29, 1810–died June 7, 1907," and "In memory of Maria Andrea Price, native of California, born January 11, 1829–died August 10, 1912, Rest in Peace." The Prices owned Rancho El Pismo. His will stated: "I direct my body be embalmed and buried in the Ocean View Catholic Cemetery at Pismo aforesaid and I direct my executors to erect in the same place, for my body and that of my wife a vault, sepulcher or monument of some durable material at a cost of one thousand dollars." Price had given the cemetery to the church. It is now known as St. Patrick's Cemetery in the city of Arroyo Grande. His great-grandchildren, the Bushnell girls, are seen visiting the site around 1948. (JH.)

The police department was housed at the city hall until moving to Halcyon Road, where it was dedicated during a ceremony on June 16, 1973. (SCHS.)

Patrol of the city was conducted in a black police car with a badge decal on the front doors in the 1950s. Prior to the installation of a radio system, officers would watch for a rotating red beacon atop the former bank building, which was illuminated by the dispatcher when there was a need for service. Officers would then go to the station or call to obtain the necessary information. (Jim Clark.)

Police officer Dan Wulfing stands next to his white patrol car at the rear of city hall in the early 1970s wearing a tan uniform. (Jim Clark.)

Emergency medical response was provided by the Central Coast Ambulance Service, which served San Luis Obispo and the Arroyo Grande areas. This type of private service was popular until the development of a paramedic program and enhanced participation of medical care by the fire department. (SCHS.)

The highway was built in 1935 on Traffic Way, which bypassed the downtown merchants. The Log Cabin carried groceries, especially fresh fruit and vegetables, as well as the Associated Oil Company's gasoline, oil, and other products. (Billie Swigert Collection.)

The Log Cabin, at the intersection of Bridge Street and Oceano Road, opened in January 1933 and was owned by C. J. Merry from Fresno. He brought an employee with him from Fresno named Tom Swigert. Swigert would eventually buy Merry out and marry Billie Records. (Billie Swigert Collection.)

An early photograph of Branch Street is shown above with some modernization seen in the form of concrete sidewalks, at least in front of the bank. (City of Arroyo Grande.)

A modern photograph of Branch Street shows a striking resemblance to days gone by. The village area remains a source of pride for the community, as evident in the retention of many of the original structures. (Rita Wagner.)

As early as 1886, there is evidence that Pat Manning operated a restaurant in the portion now occupied by O'Conner Realty. Pete Olahan's Pioneer Liquor House was the side that is now Ira's Bike Shop. The building has been moved to the back of what had been the bank building nearer the creek. (SCHS.)

Ruth Paulding is seen on September 30, 1975, during the Paulding campus dedication ceremony, when the school was named in her honor. Today it is Paulding Middle School. (PHH.)

The Arroyo Grande Harvest Festival began in 1937 and remains one of the largest annual events in the community. It was created by the Women's Club and was cause for celebration, including vintage costumes and a parade. A few past grand marshals of the Harvest Festival are honored at a Women's Club tea. Pictured from left to right are (first row) Ann Silva and Georgie O'Connor; (second row) John Silva, Gladys Loomis, Peggy Porter, and Charles Warner. (SCHS.)

Shown left to right, Dorothy Dana, Ruth Paulding, and Maude Loomis look over a display of old pictures during a Harvest Festival exhibit. (*Times-Press-Recorder.*)

Society editor Mae Ketchum (left) is pictured with editor Richard Blankenburg Sr. and Lois Blankenburg ready to join the parade. (SCHS.)

Jack Schnyder was a local blacksmith who gave to local children, including the high school swimming pool, even though he had no children of his own. His iron work appears all around the village. This photograph depicts Schnyder's entry into the Harvest Festival as his float. (*Times-Press-Recorder.*)

Mr. and Mrs. William Vaughn of Vaughn's Jewelry won the trophy for Best Costume during the 1955 Harvest Festival. (*Times-Press-Recorder.*)

Ralph and Muriel Bennett are dressed up as grand marshals for the 1958 Harvest Festival parade and activities. (*Times-Press-Recorder.*)

A humorous entry in the annual Harvest Festival parade is the lawn mower drill team sponsored by Miner's Hardware store. (Vivian Krug.)

In costume from left to right are Barbara Vincent, Barbara LeSage, Billie Swigert, Mary Ann Filler, Jean Hubbard, Elsie Loomis, Ethel Gilliland, and Margaret Haak. Each historical society woman represents a lady of the past. (SCHS.)

Vivian Krug and Sam Cotton pose in "Old West" costumes during the annual Harvest Festival and parade in 2008. (Ross Kongable.)

The annual Strawberry Festival draws thousands of participants who crowd the streets, which have been blocked off from vehicle traffic. Vendors and concessions fill the air with the pleasant smell from barbeques and feature nearly any type of treat conceivable that uses strawberries. (Vivian Krug.)

The Rotary Bandstand is the venue for a series of free concerts throughout the summer, including one above featuring the Gold Coast Choir. (Vivian Krug.)

If people are there, the South County Historical Society is there. Ross Kongable tastes some of his famous popcorn, which is a true crowd pleaser. (Vivian Krug.)

The Heritage Square Park surrounding the Rotary Bandstand is a picturesque location for concerts and entertainment. The park adjoins several properties operated by the South County Historical Society, including Ruby's House, the Barn Museum, Santa Manuela Schoolhouse, Heritage House Museum, and the Branch Millstone exhibit along the serene creek walk. (Vivian Krug.)

The city of Arroyo Grande has had much cause for celebration, including the recognition of the 100th anniversary of the Bridge Street Bridge crossing the creek in the downtown area. Pictured from left to right are Bee Hodges, Bill Hart, Vivian Krug, Chuck Fellows, Berneda Cochran, Whitney Fritzly, Jane Line, and Joe Timmons. (Vivian Krug.)

The beauty of the historic village area is striking in the evening looking east on Branch Street during the Christmas season. The roof lines of the largely historic buildings are highlighted with Christmas lights. (Vivian Krug.)

A sad dose of modern society found its way to Arroyo Grande when officer Richard Berry was killed by a drunk driver on December 22, 2002. Ironically, Richard was an expert on the enforcement of laws prohibiting driving under the influence and was recognized for his work in traffic safety. A flagpole and monument were erected in front of the police station on Halcyon Road in his honor. (Both GH.)

Funeral Service of

Arroyo Grande Senior Police Officer

Richard Alan Berry

Badge #40

Born - February 5, 1956
Dugway, Utah
End of Watch - December 22, 2002
Cuesta Grade, California

The 1902 IOOF Hall has been restored and seismically retrofitted by the South County Historical Society. It features a series of rotating exhibitions and events. (Vivian Krug.)

Five

SOUTH COUNTY HISTORICAL SOCIETY

Founded in 1976, the South County Historical Society is dedicated to the research, restoration, and dissemination of information so that our historical heritage may be enhanced and preserved. Incorporated as a nonprofit public benefit organization, the society serves the entire southern San Luis Obispo County. Included in the sphere of influence are Edna, Avila Beach, Shell Beach, Pismo Beach, Grover Beach, Huasna, Oceano, Nipomo, and Arroyo Grande. Boasting a membership of nearly 500, the society plays an active role in the community in the area of historic preservation and research.

The property holdings of the society are substantial and historically significant. The organization owns the 1902 IOOF Hall building, the 1889 Paulding History House, and the 1901 Santa Manuela Schoolhouse, and it leases the 1895 Heritage House and Ruby's House. There are a number of vehicles in the society fleet, including a 1923 fire truck, several tractors, and several horse-drawn carriages.

Virtually every community event has representation by the historical society board of directors, docents, or members. With a very active docent and volunteer crew, the society enjoys many opportunities to help the community and ensure the high quality of life that is cherished on the Central Coast. From the Harvest Festival, Strawberry Festival, Christmas in the Village, schoolhouse tours, and several museums to the historic research center and library, the society is a core component of the community and City of Arroyo Grande. Often donning period costumes, the society members take a high profile in serving the community. Membership is always open, and it is a great way to become involved regardless of one's age.

The Santa Manuela Schoolhouse was built in 1901 on a corner of the Joseph Jatta property, which is now under Lopez Lake. The one-room schoolhouse was in use until 1957. The historical society obtained the building in 1977 and moved it four times. It is currently located on Short Street adjacent to the swinging bridge in the Heritage Square area. (Vivian Krug.)

Santa Manuela Schoolhouse is open to the public on weekends and for special events throughout the year. Pictured above from left to right are docents Lia Kalpakoff, Kathleen Sullivan, and Siena Fiorentino. (Vivian Krug.)

The Heritage House and gardens, built in 1865, serve the community as a historic structure and museum. Many exhibits and displays are open to the public and staffed with volunteer docents. Heritage House has been used as a hospital, and one of the local newspaper editors lived there for 20 years. (Vivian Krug.)

The garden adjoining the Heritage House, a popular site for wedding and outdoor functions, is noted for its beautiful landscaping and serenity. Above is one of the many functions at the site with the newlyweds Jill and Scott Bratcher walking down the aisle from a ceremony performed in the gazebo. (Jill Bratcher.)

Ruby's House is owned by the City of Arroyo Grande and leased to the historical society for use as a community historic research center and library as well as administrative offices. The building underwent a complete restoration and upgrade to preserve the integrity of the historic structure and to adapt it to use by the society and community. (Vivian Krug.)

Ruby's House is officially named the Patricia Loomis History Library and Research Center. Completion of the restoration resulted in a grand opening ceremony. Standing from left to right are Gary Scherquist, Pres. Jane Line, Vivian Krug, Edie Juck, Ross Kongable, Jan Scott, Kathleen Sullivan, Charles Porter, and Michael Drees. (Vivian Krug.)

The Barn Museum was constructed in the historic village green area to highlight the area's farming and ranching roots. (Vivian Krug.)

Former society president Kirk Scott sports a very stylish period costume while seated in one of the historical society's horse-drawn carriages on display at the Barn Museum. The Barn Museum was constructed while Kirk Scott was president. (Vivian Krug.)

The spaciousness of the Barn Museum has also lent itself well to educational programs and demonstrations, such as the one presented above on September 12, 2004. (Vivian Krug.)

Many of the artifacts on display in the Barn Museum are from the rougher side of society, including farming implements, tools, and saddles, which highlight our agricultural heritage. (Vivian Krug.)

Longtime society member Barbara LeSage dons a costume and helps visitors in the barn museum. (Vivian Krug.)

Jim Bergman navigates a fully restored tractor he and a team of high school students restored for a competition at the Mid-State Fair. The tractor was donated to the historical society and makes regular appearances at community events. (Vivian Krug.)

This 1923 American LaFrance fire truck is on display in the Barn Museum. The engine is frequently driven in parades throughout the region and is maintained in great working condition. (Vivian Krug.)

Spectators, including Bob Lund (right) and an unidentified museum patron, seem to enjoy the detail of the many artifacts on display at the Barn Museum, including this antique horse-drawn carriage. (Vivian Krug.)

This 1885 Eastlake-style pump organ is on display in the Heritage House Museum and had resided in the Fred Marsalek family home in the early 1900s. (Vivian Krug.)

The silk wedding dress on the left is displayed in the Heritage House and was used between 1920 and 1940. It is part of a seasonal rotating exhibit within the museum. (Vivian Krug.)

Dr. Edwin Paulding was the first permanent medical doctor in Arroyo Grande, arriving in 1883. He married Clara Edwards, and they purchased the house at 551 Crown Hill in 1891; it had been built two years earlier. Their daughter, Ruth Paulding, was born in the house and taught many years in Arroyo Grande and Watsonville. She died in 1985 at the age of 93 in the same house. (Vivian Krug.)

On her 82nd birthday, Ruth Paulding bequeathed her home to the San Luis Obispo County Historical Society. To best care for the property, ownership was transferred to the South County Historical Society, which was celebrated during a ceremony on September 26, 1998. The house is preserved as a living museum, maintained in its original state. (PHH.)

The 1902 IOOF Hall underwent a lengthy restoration and seismic upgrade and serves as an exhibit hall and curatorial quarters for the South County Historical Society. (Vivian Krug.)

A construction wall stood in front of the IOOF Hall during the restoration project and was ceremoniously removed in 2007. Shown from left to right during the wall removal event are Howard Mankins (project director), Jane Line (president), Charles Porter, Vivian Krug, and Gary Hoving. (Ross Kongable.)

121

A historical researcher reviews records from the society's substantial holding of local historical source documents. Included in the collection are historic newspapers, government documents, books, photographs, and artifacts from throughout the South County area. (Vivian Krug.)

One of the oldest known Mexican artifacts in the collection held by the historical society is the Branch Millstone. It was acquired by the society and placed on permanent display in a professionally designed monument and marker along the Arroyo Grande Creek Walk adjoining the Heritage House, Barn Museum, and Santa Manuela Schoolhouse. Pictured above from left to right are Jean Hubbard, Vivian Krug, Paulette McCann, Jane Line (president), Gary Hoving, Anita Garcia (great-granddaughter of F. Z. Branch), Joe Swigert (great-great-grandson of Branch), Charles Fellows, and Amy McKay (project architect). (Ross Kongable.)

Dressed in period costumes on the Heritage House grounds from left to right are Margaret Haak, June Waller, and Mary Ann Feller. (Vivian Krug.)

One of the annual fund-raising events is an antique show held in February. Many of the docents and society members help make the function a wonderful success and enjoyable for the dealers and attendees. Charles Silva performs his duties in costume, which adds to the ambiance of the event. (Vivian Krug.)

The historical society has joined the Christmas in the Village program. Merchants keep their shops open into the evening and shoppers are greeted with hot cider and treats from cheerful volunteers. Society members above are, from left to right, Ross Kongable, Martin Line, Joe Swigert, Paulette McCann, Colleen Drees, Norma Burton, Jane Line (president), and Michael Drees. (Vivian Krug.)

The South County Historical Society celebrated its 32nd birthday in 2008, which was cause for a cake at the annual Founders Day Barbeque. (Vivian Krug.)

Six
CENTENNIAL CELEBRATION

From a modest beginning in 1911, the City of Arroyo Grande has maintained much of its original charm and many of the early buildings. Cityhood was approved by the voters by a margin of only two. Support for the city and its mission remained of primary concern to all citizens regardless of the original vote.

A balance has been well maintained between protecting the heritage of the community and planning its growth by the City of Arroyo Grande. It hosts many of the larger retail conveniences while protecting the original village commercial district much as it would have been viewed 100 years ago. This is no easy task in modern times of fiscal challenges and limited resources for a city government. However, the city staff has been on the forefront of programs and initiatives to maintain the quality of life found by the residents and many visitors to the community.

As evident to any regular visitor to the community, the city of Arroyo Grande is always poised for a celebration. Such is the case as the city celebrates the milestone of 100 years of service to citizens of Arroyo Grande. Such a milestone is a remarkable achievement, and the centennial celebration will be filled with activities, ceremonies, and events that will continue to build pride in this wonderful community.

Visitors to the city of Arroyo Grande are greeted with attractive signs around the borders of the community. (Vivian Krug.)

Many favorite treats are prepared during the annual Strawberry Festival drawing attendees from throughout California. (Vivian Krug.)

No history would be complete without a photograph of one of the "pet" chickens that reside and roam throughout the village area and adjoining creek. (Vivian Krug.)

DISCOVER THOUSANDS OF LOCAL HISTORY BOOKS
FEATURING MILLIONS OF VINTAGE IMAGES

Arcadia Publishing, the leading local history publisher in the United States, is committed to making history accessible and meaningful through publishing books that celebrate and preserve the heritage of America's people and places.

Find more books like this at
www.arcadiapublishing.com

Search for your hometown history, your old stomping grounds, and even your favorite sports team.

Consistent with our mission to preserve history on a local level, this book was printed in South Carolina on American-made paper and manufactured entirely in the United States. Products carrying the accredited Forest Stewardship Council (FSC) label are printed on 100 percent FSC-certified paper.

MADE IN THE USA